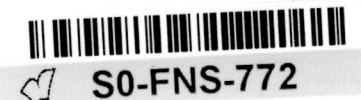

IMAGES of America

FREDERICKSBURG AND SPOTSYLVANIA COURT HOUSE

The town of Fredericksburg and its surrounding topography lent itself to become the stage for a bittersweet contest between north and south. This map is from the *Atlas to Accompany the Official Records of the War of the Rebellion*. (JFC.)

IMAGES
of America

FREDERICKSBURG AND SPOTSYLVANIA COURT HOUSE

John F. Cummings III

Copyright © 2002 by John F. Cummings III
ISBN 978-0-7385-1484-0

Published by Arcadia Publishing

Charleston, South Carolina

Printed in the United States of America

Library of Congress Catalog Card Number: 2002112607

For all general information contact Arcadia Publishing at:
Telephone 843-853-2070
Fax 843-853-0044
E-mail sales@arcadiapublishing.com
For customer service and orders:
Toll-Free 1-888-313-2665

Visit us on the Internet at www.arcadiapublishing.com

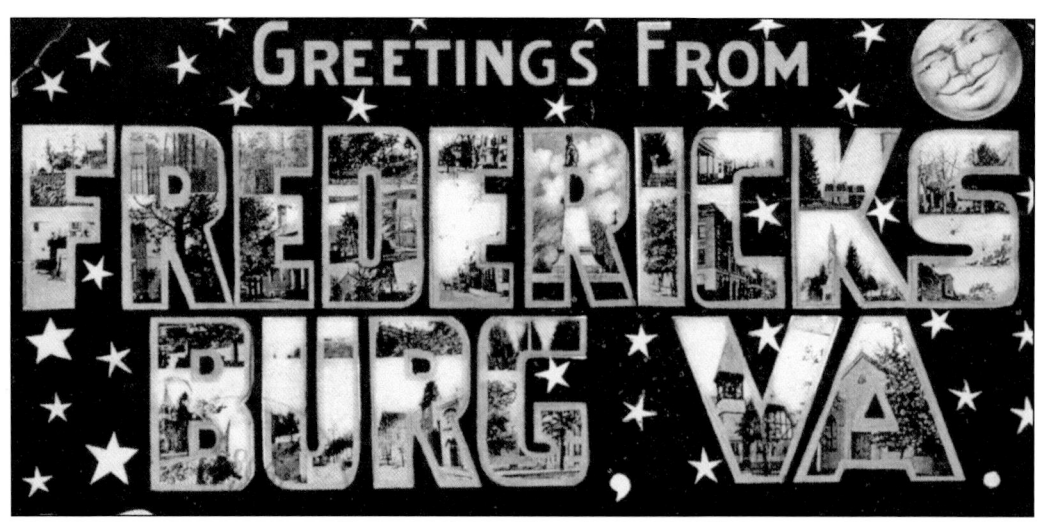

This early postcard promoting Fredericksburg is dated 1908. (JFC.)

CONTENTS

Acknowledgments		6
Introduction		7
1.	Calm Before the Storm	9
2.	War Comes to Town	21
3.	Spotsylvania Court House	35
4.	The Phoenix Rises	49
5.	Memento Mori	117
About the Author		128

ACKNOWLEDGMENTS

I would be horribly remiss if I were not to acknowledge the kind and generous guidance received from Noel Harrison. While serving as a cultural resource historian for the National Park Service, Noel entertained on countless occasions not only my questions, but also my theories about the Fredericksburg region's many treasures. Upon coming to town in 1999, I was welcomed by Mr. Harrison and it is due to his friendship that my otherwise novice interest in cultural resources was able to flourish and mature to the all-consuming passion that I find myself exhibiting today. Noel certainly blazed numerous trails with his own studies and therein he has provided a tremendous legacy for us all to learn from.

My wife, Karen, deserves more gratitude than I could ever express in mere words. As my confidant and very capable research assistant, she has accompanied me on my journeys through libraries, archives, and explorations of terra firma, during times of extreme heat and winter chill. Thank you.

I must also acknowledge the assistance, guidance, and comradeship from the following individuals: Eric Mink, Donald Pfanz, John Hennessy, Anne Ligon, Robert Lee Hodge, Kim Timmerman, Agnes McGee, James and Ellen Anderson, Bill and Elva Horn, Edward Bell, Cathy Morgan, Merl Witt, Caroline DeMunnick, Hal and Jody Wiggins, William D. Matter, Gordon Rhea, Jack Edlund, James McElhinney, Barry McGhee, Valerie Bell, Julie Bell, Alphonse Vinh, Cindy Lowe, Andrea Clayton, Michael W. Kauffman, John and Saundra Cummings, and my mother in Heaven, Mary Feril Cummings.

The following abbreviations after picture captions will provide picture sources: (JFC), the author's collection; (AL), Anne Ligon; (CM), Cathy Morgan; (JB), Julie Bell; (CPM), Catherine P. Miller; (AD), Altamont Dickerson; (NPS), National Park Service; (LC), Library of Congress; (NMHM), National Museum of Health and Medicine; and (VB), Valerie Bell.

INTRODUCTION

For Fredericksburg, Virginia, the Victorian era meant three things—the realization of a long-sought economic revitalization, severe physical and financial damage from war, and an economic and social rebirth leading into the Edwardian Age. From 1845 to 1909, the town experienced the best of times and the worst of times. This volume is intended to provide a photographic survey of the town's social context during those years.

Outside of passing mention, no attempt will be made to detail Fredericksburg's Colonial roots, as that would necessitate a study unto itself. The effect wrought by the War Between the States on the region was one of sheer bedlam and an outrage to the civilian population. This volume will not be a history of the military strategy that brought on this destruction. The purpose herein is to portray a town and its people, and to illustrate the endearing perseverance that made things right again. To that goal, we will focus on the physical remains of the region's cultural heritage—homes, businesses, places of worship, mass transportation, and industrial facilities. Through pre-war prosperity, devastation, and recovery, we will look at the lives that once resided here and the remains that remind us of what was.

A propelling force behind this work is the creative output left by three local postcard publishers. Their product helped to provide a vivid document of the people and the town they inhabited. One of the most prolific card publishers was Robert A. Kishpaugh, a printer and stationer. His contemporaries were Joel Willard Adams and Dr. William L. Bond. Combined, they created an archive that has served as a visual memoir.

By the eve of the Civil War, Fredericksburg was coming of its own as an economic center. It had taken nearly 50 years to achieve this revitalization. The once-thriving Colonial-era port had been eclipsed by the cities of Alexandria to the north and Richmond to the south. Just a few years before the town would experience the ravages of America's defining drama, it was enjoying a promising industrial boom.

Fredericksburg was not yet an independent city but a town within the county of Spotsylvania. In 1860, Spotsylvania County had an aggregate white population of 7,716, almost evenly divided by the sexes. The addition of 574 free blacks and 7,786 slaves more than doubled the population for a total aggregate of 16,076.

Fredericksburg itself was home to 5,022 people. Of the whites in Spotsylvania, 574 were of foreign birth. Among those was John Henry Myer from the Kingdom of Hannover. Myer would become one of Fredericksburg's most successful merchants and a community leader, serving 30 years on the post-war Common Council. The focus of this book will be the people and places

that comprised Myer's world. Myer was one of those strong-willed individuals who, despite personal adversity, helped bring Fredericksburg out of ruin.

On the other side of the racial divide, this book will visit the experiences of Joseph Walker. Walker was born a slave on a Spotsylvania plantation, witnessed the battles that raged around him, and in freedom lived an exemplary life that would place his memory firmly in the shrine of virtues.

Strength of character displayed by individuals like Myer and Walker would set the example that propelled Fredericksburg into the 20th century.

Utilizing a large photographic and illustrative collection, along with numerous "then and now" comparisons, this book will graphically portray the juxtaposition of days gone by to our modern landscape.

One
Calm Before the Storm

John Henry Myer came to America from the Kingdom of Hannover and settled in Fredericksburg in 1846. He quickly proved himself an adept businessman. In later years, he would find time to serve on the Common Council to give back to the community that patronized his enterprises and sustained him and his family.

By 1860, the Fredericksburg region was full of hope for many people. Things had changed dramatically since the previous century, but with a burgeoning industrialization, both large and small businesses began to appear, making this already historic spot below the Rappahannock fall line even more promising.

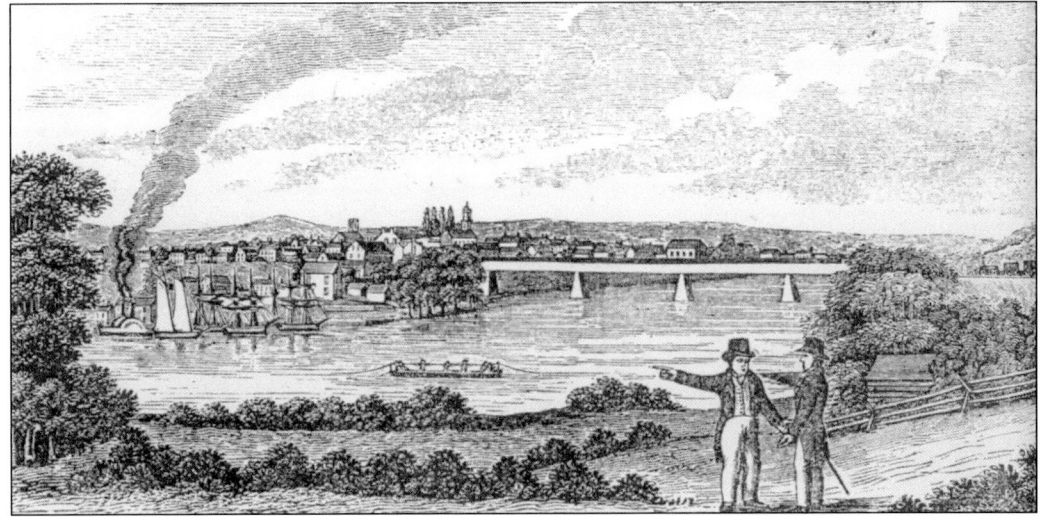

This is a mid-1840s depiction of Fredericksburg as seen from Ferry Farm, the boyhood home of George Washington. This somewhat idealistic depiction of the town appeared in *Howe's Collected History of Virginia*. At right, a steam train approaches. Across the Rappahannock River, a number of merchant vessels are anchored at the dock while the ferryboat connects with the Stafford County shore. Although not impoverished, Fredericksburg was working hard to revitalize its sagging economic position amongst cosmopolitan urban communities like Richmond and Alexandria. (JFC.)

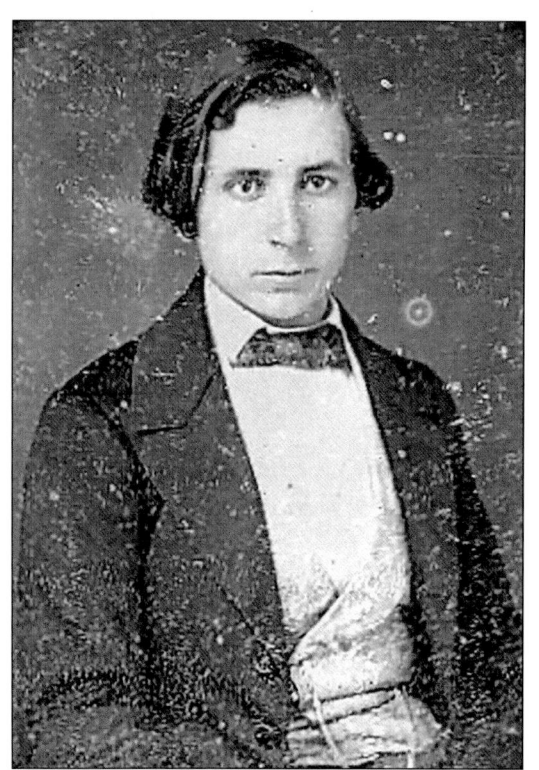

In what is almost undoubtedly the first photograph of John Henry Myer, we are taken by his youthful, determined countenance. This daguerreotype shows him in his early 20s. When Myer came to town, he began his professional life as a saddler. In 1852, he would oddly change his vocation to baker and confectioner. This suited him well, and by the 1860 census, he was out-producing his competition many times over. (AL.)

With this financial success, Myer began to purchase property bordering the town's Market Square. This three-story brick building served as his primary business address while his family resided in the upper floors. The building is at 212 William Street, alternately known as Commerce Street. This photograph was taken while occupied by a subsequent confectioner, L.L. Layton. (JFC.)

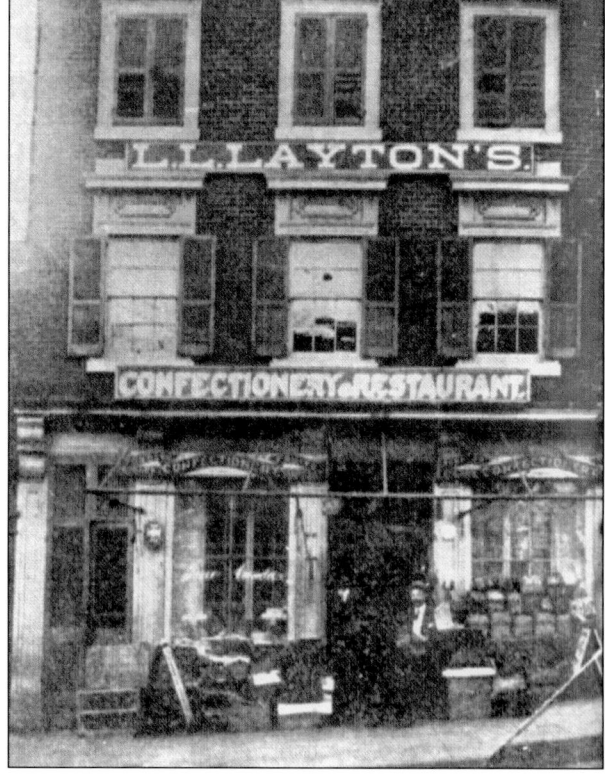

Three of Myer's children lived to adulthood while three others died before the age of two. In this pre-war ferrotype are, from left to right, John Jr., Mary, and Annie. John Jr. died in 1900 of appendicitis at the age of 48. Mary wed a gentleman named Hamilton John Eckenrode, who made his fortune as a haberdasher. They would have several children. Annie, on the other hand, never married, but died at age 92 in 1946. She was a highly conscientious citizen and contributed to many charitable efforts throughout her long lifetime. (AL.)

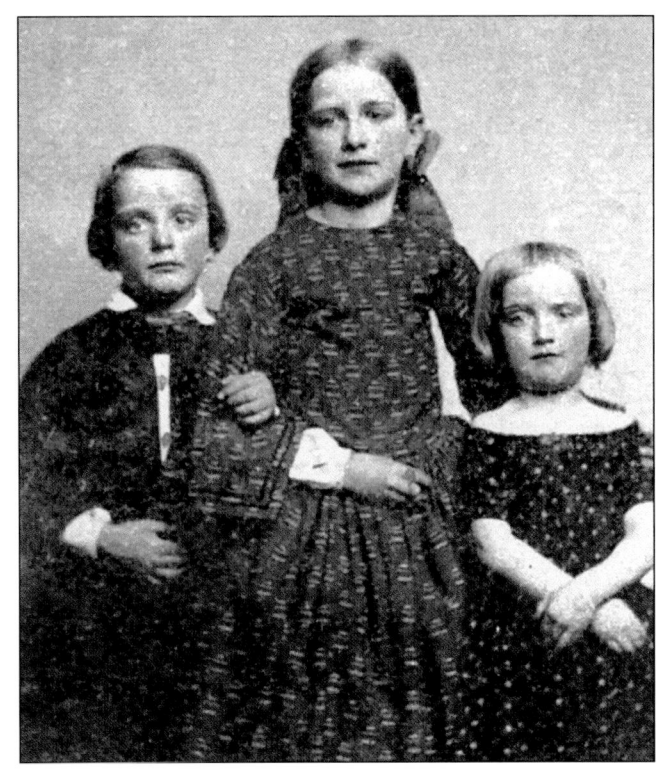

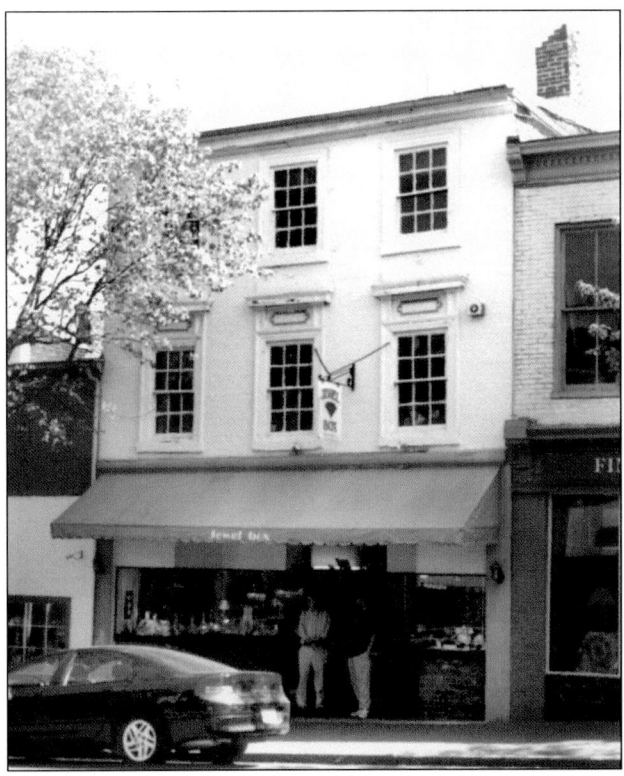

Here is the Myer residence as it appears today. It is currently a jewelry store. The street level has been many times altered over the years, yet the upper stories have retained most of their facade features. The building stayed in the Myer family into the mid-1900s. (JFC.)

11

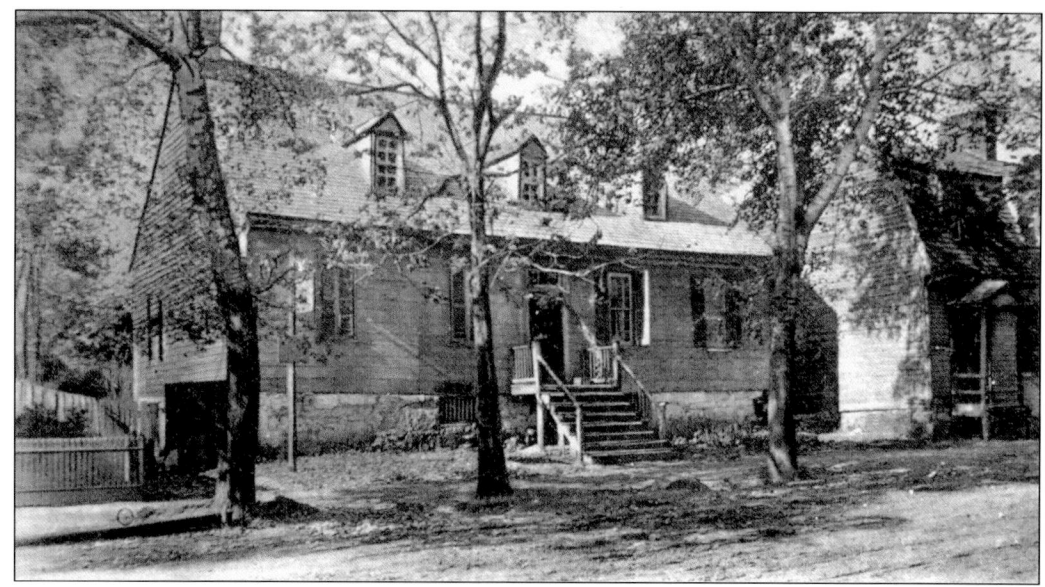

Many of Fredericksburg's structures date back to the Colonial era. Seen here is the Rising Sun Tavern, upon whose floors trod numerous revolutionary personalities on visits to the area. The structure was originally built by Capt. Charles Washington, brother of George Washington. (JFC.)

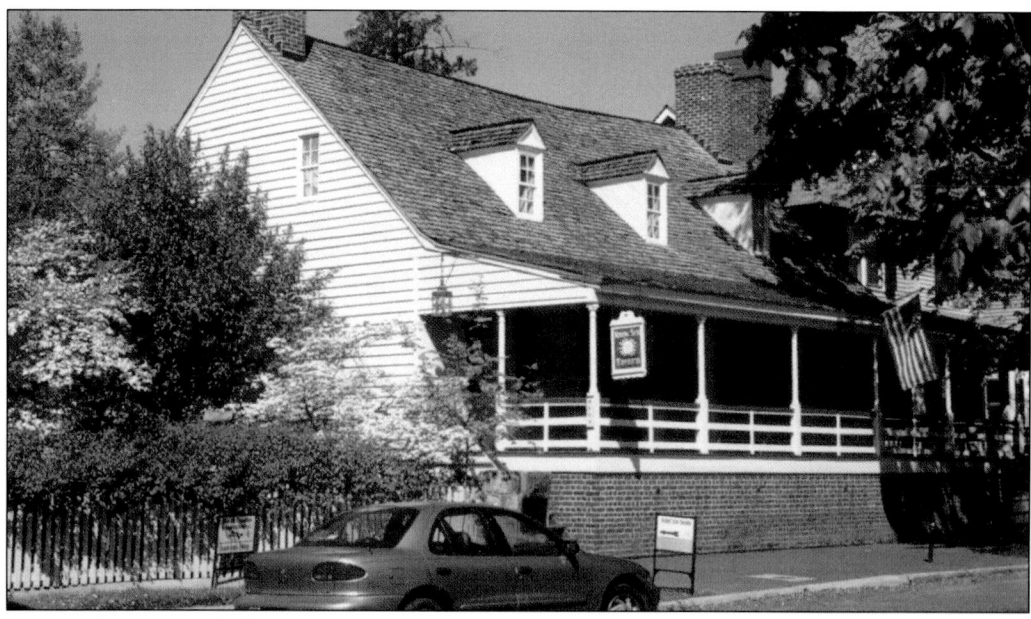

Having been spared the ravages of time, the Rising Sun Tavern was purchased and restored by the Association for the Preservation of Virginia Antiquities (APVA). Annie Myer was a member of the APVA as well as many other civic organizations, including the United Daughters of the Confederacy. Today the tavern has had its 18th-century porch rebuilt giving it a strikingly different appearance from its late Victorian face seen in the previous photo. (JFC.)

Three towering spires dominate the Fredericksburg skyline. St. George's Episcopal Church is the oldest, having been erected in 1849 on Princess Anne Street, between the Town Hall and the Circuit Court building. Directly across the street from it was the Farmer's Bank of Virginia, known today as the National Bank of Fredericksburg. (JFC.)

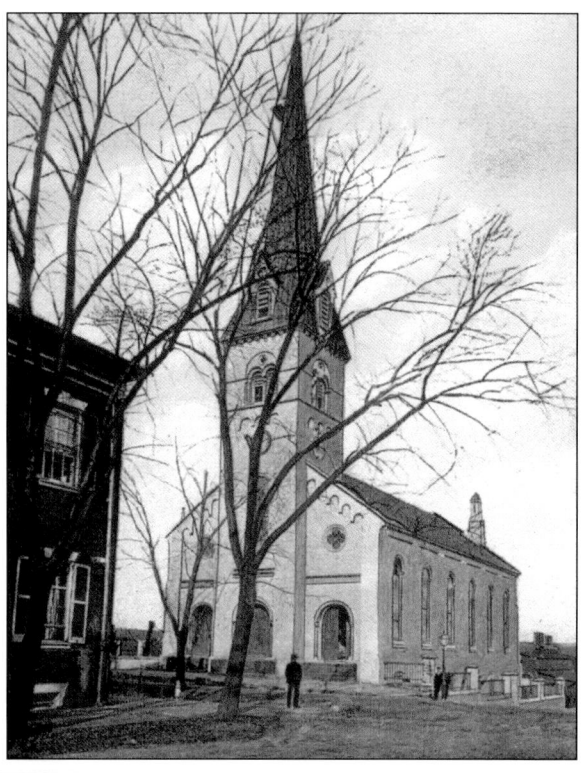

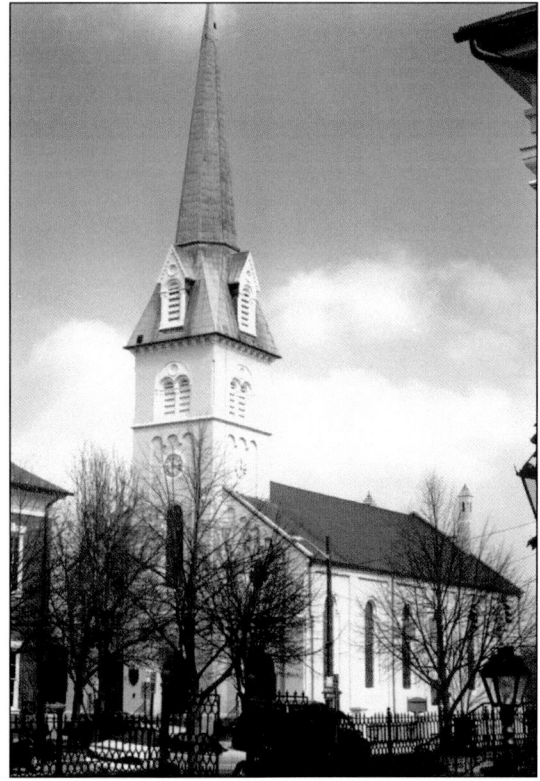

Behind St. George's lies the Market Square. The church graveyard was once adjacent to this commercial venue. Church expansion in the 1950s made it necessary to relocate the graves. The spire also contained the town clock. During the Battle of Fredericksburg in December 1862, it is said that Union artillery was deterred by divine intervention from making the spire a target of sport. (JFC.)

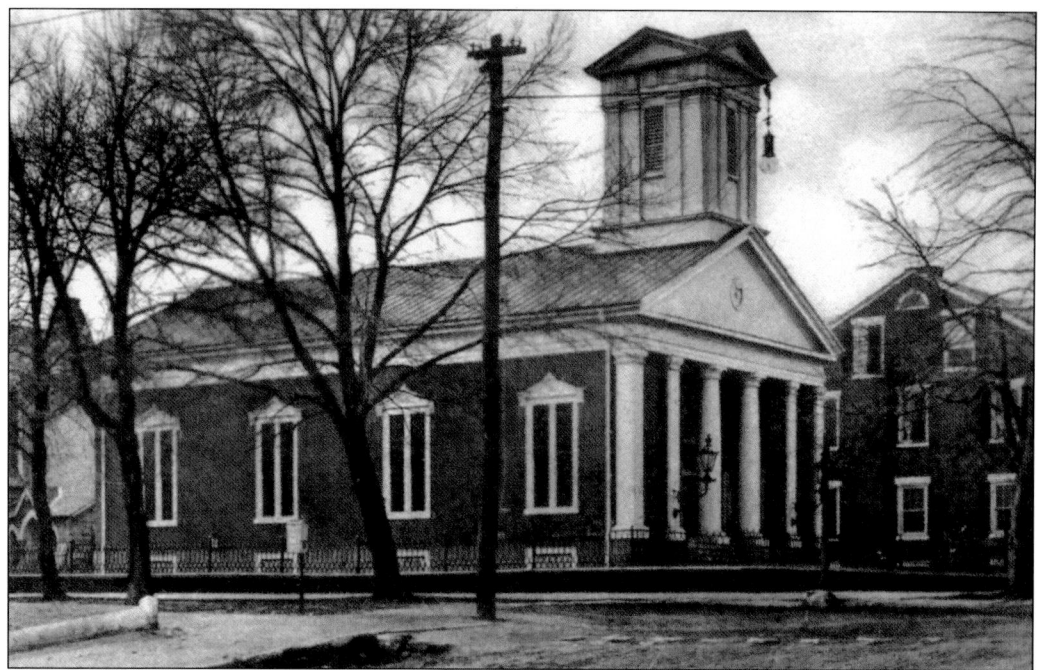

The Myer family attended the Presbyterian Church located diagonally across Princess Anne Street from St. George's. It was erected in 1833 and withstood the onslaught of Federal artillery. Several projectiles are still lodged in its columns and bell tower. (JFC.)

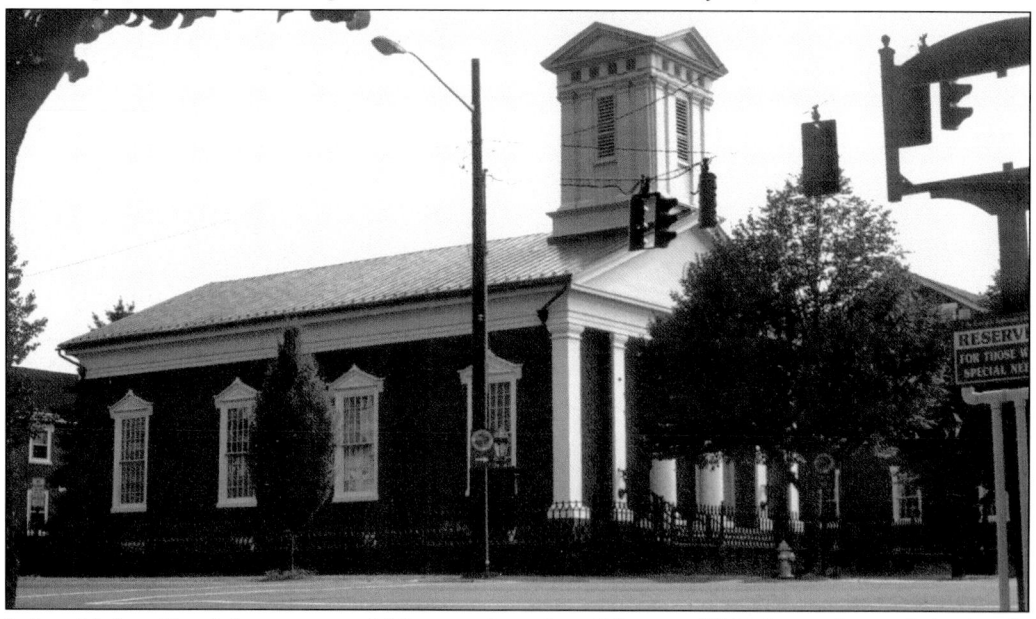

It is said that Confederate general Thomas Jonathan "Stonewall" Jackson planned the battle of Fredericksburg from this street corner. A plaque asserting this is mounted on the brick wall that surrounds the yard. Jackson was a devout Presbyterian himself and in the months before the battle, this church and all others in town were filled on Sundays with soldiers anxious for redemption. As with all large buildings, the church was used as a hospital after the conflict. (JFC.)

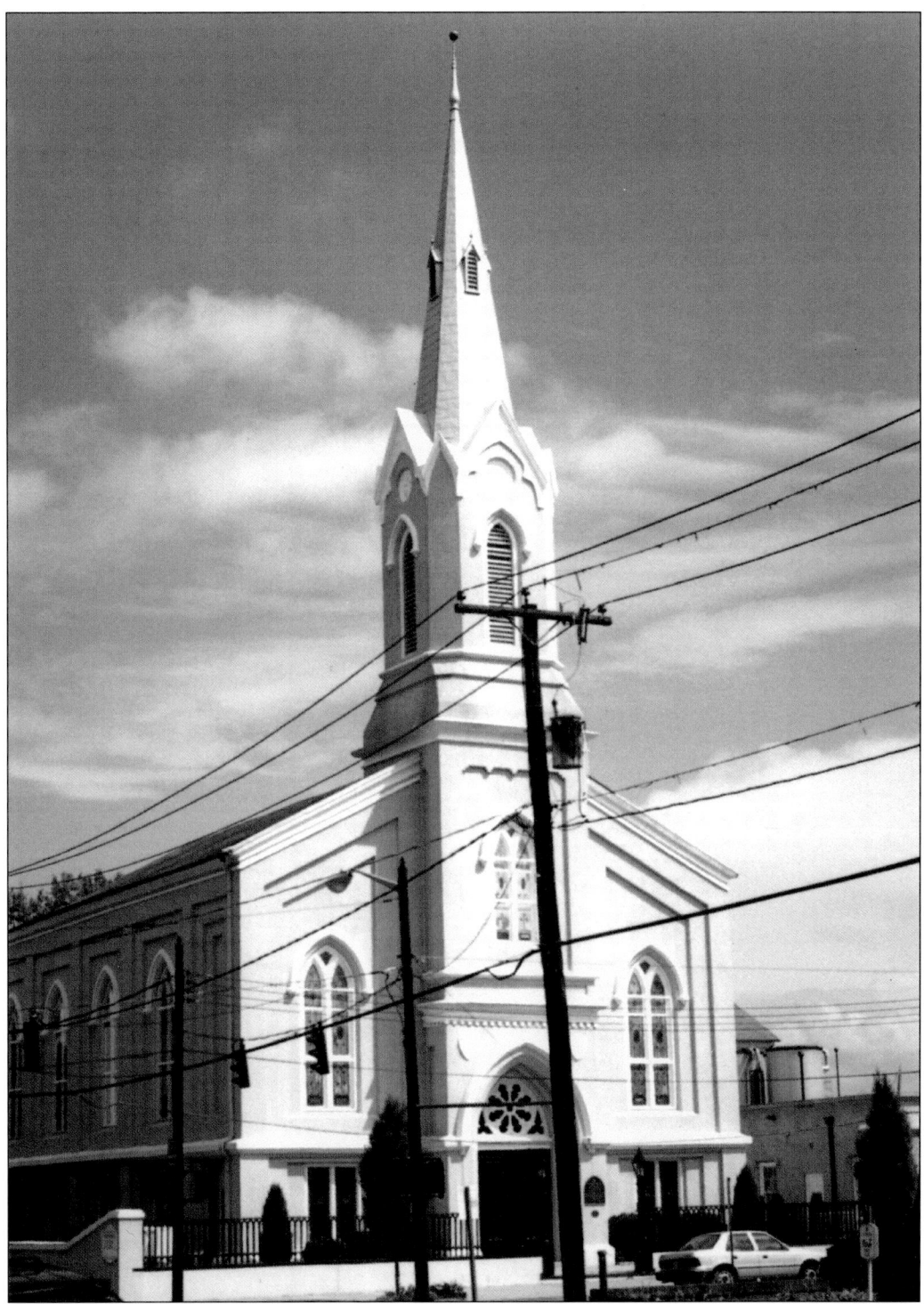
The Baptist Church on the corner of Amelia and Princess Anne Streets would be used as a signal station and observation post for the Union Army. Its aisles would also provide for the care of the thousands of wounded that came from the surrounding fields of battle. (JFC.)

Federal soldiers overlook Fredericksburg's skyline from Stafford Heights in this detail from a newspaper illustration drawn by special artist Henri Lovie. Seen at far right is the large brick Woolen Mill. In 1854, the Fredericksburg Water Power Company constructed a wooden crib dam on the Rappahannock to nurture new industry. The Woolen Mill was one of the town's newest employers that relied on waterpower to run its machinery. It went into operation around 1860. (JFC.)

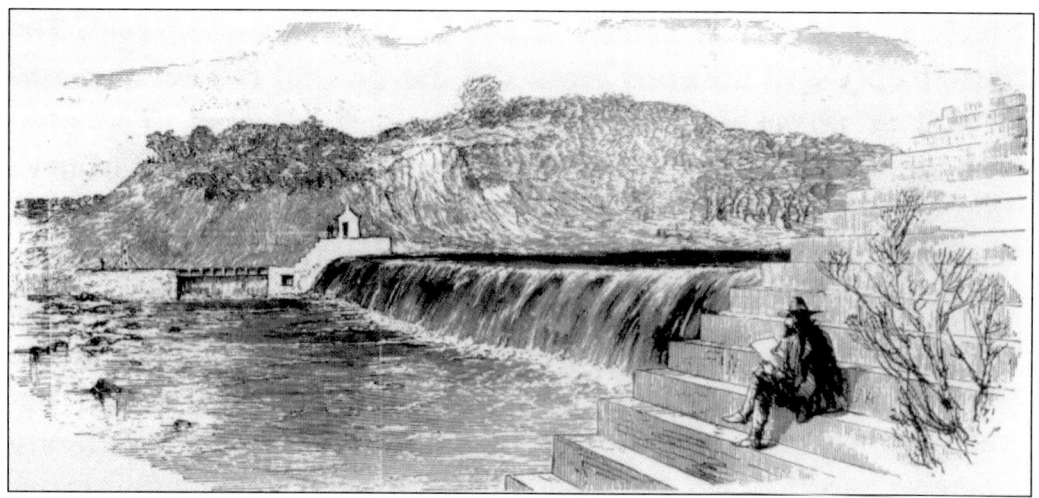

British-born newspaper artist Alfred Rudolph Waud is depicted sitting on the Stafford side of the dam. A lock system on the Fredericksburg side diverted water into a canal that ran through the northern outskirts of town and then flowed southward along its western edge to supply businesses on the south end near the railroad. (JFC.)

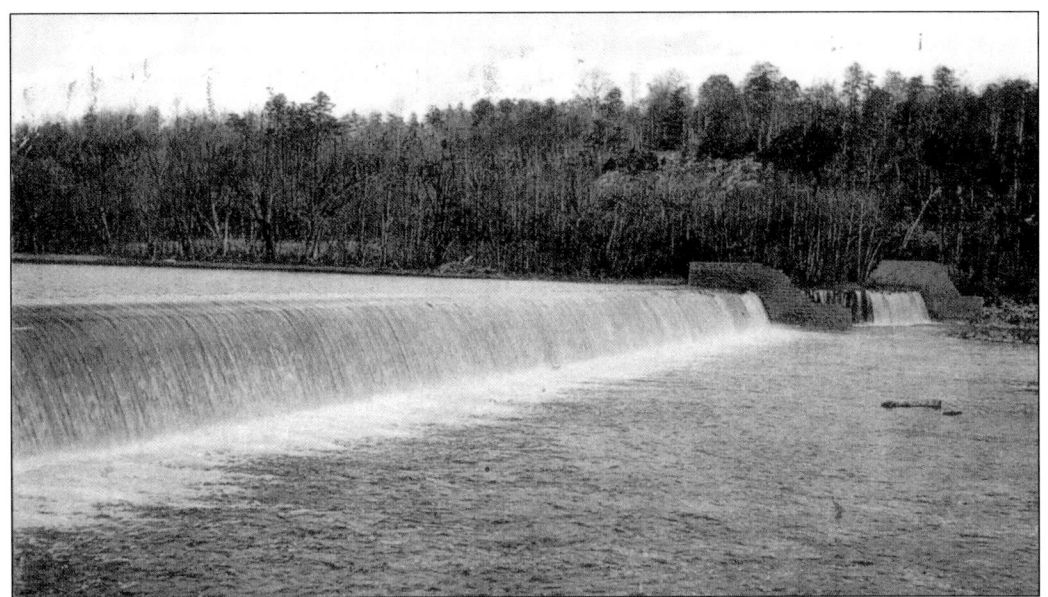

A card postmarked 1908 shows the crib dam from the Fredericksburg side. After more than 50 years of deterioration, it was determined that modernization was necessary. In 1910, the "Embry Dam" was constructed 35 feet in front of the crib dam. It was built of reinforced concrete. (JFC.)

Remains of the crib dam are visible today during times of drought as this picture from August 27, 2002 shows. Now, after another 90 years, the usefulness of either dam has expired as a source of energy. Negotiations are underway to remove them from the river, as they do little more than inhibit the passage of fish. Compare this photo to the Waud sketch on the previous page. (JFC.)

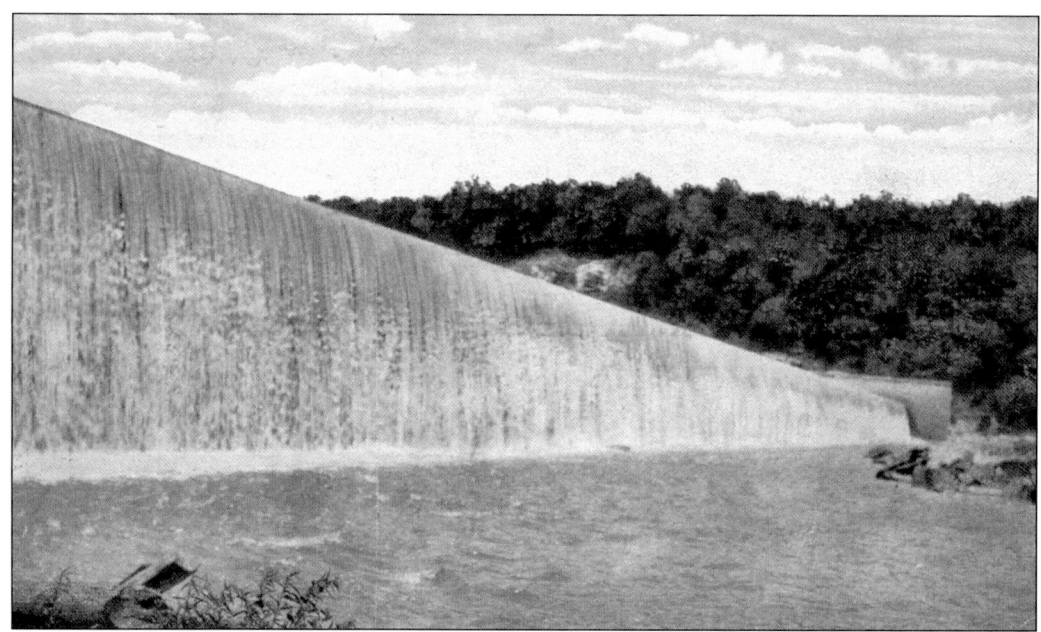
This postcard shows the massive Embry Dam with its 786-foot long spillway—over 200 feet longer than that of the crib dam. (JFC.)

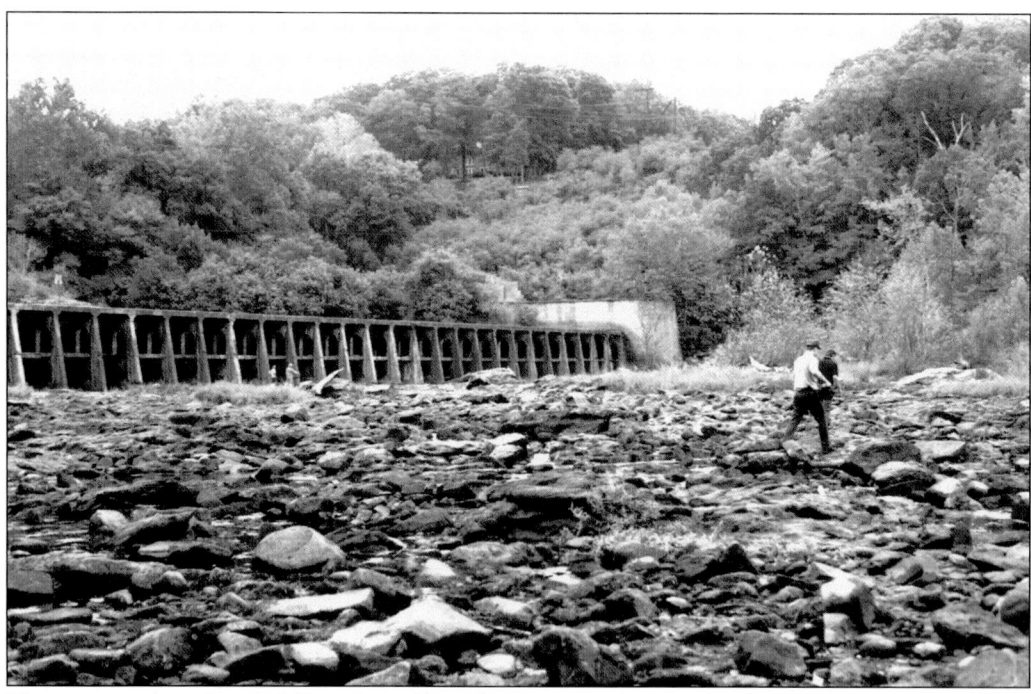
The summer drought of 2002 took a toll on the region with water levels not seen since the fall of 1930. With the river at a dramatic low, there was opportunity to study the otherwise submerged terrain. Here, city planner Erik Nelson leads National Park Service historian Donald Pfanz across the exposed riverbed. The buttressed piers that make up the Embry Dam are completely exposed in this photo of August 27, 2002. (JFC.)

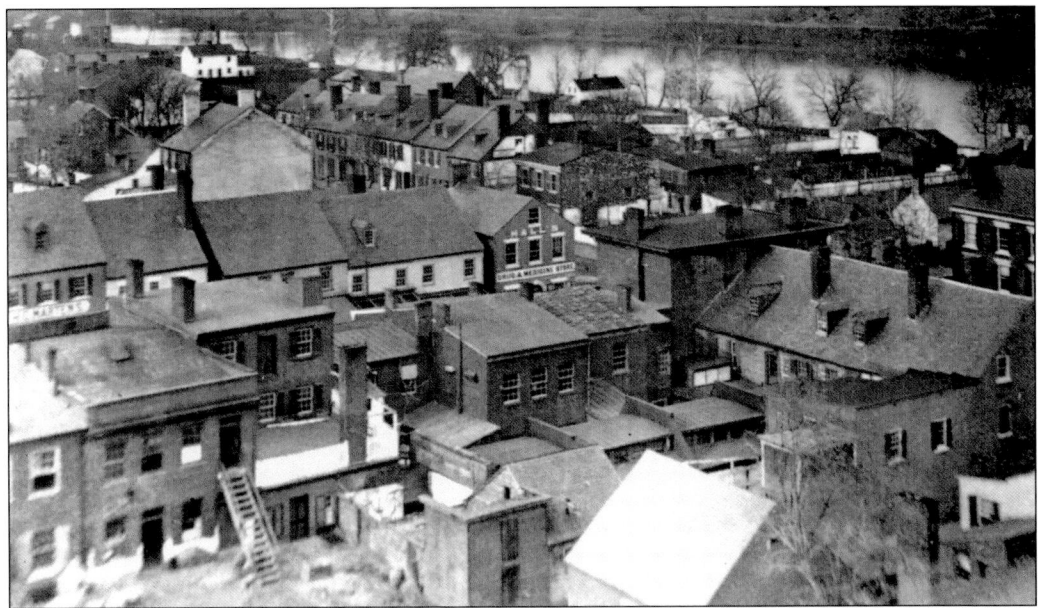

Shown here is a magnificent view of the town from the steeple of St. George's, looking north. In the immediate bottom left can be seen a portion of the Market Square. Myer's bakery is the third structure from the left, closest to the camera. The extended rear of his kitchen is visible with a fenced-in roof, possibly compensating for the lack of a yard. This image was produced around 1881 by an unknown photographer as part of a panoramic series. (NPS.)

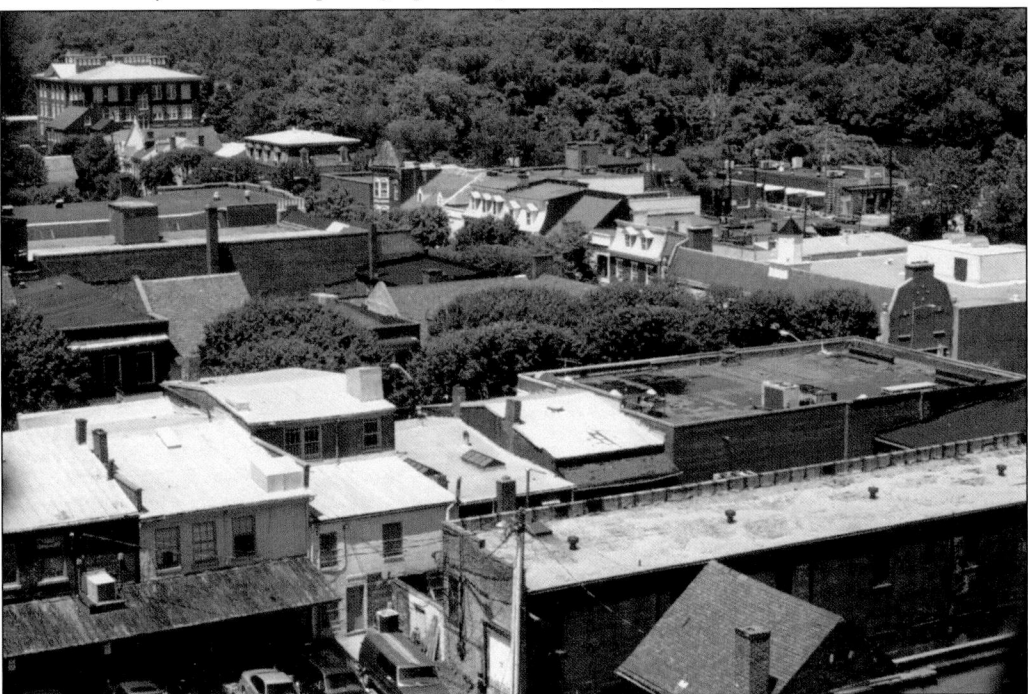

This is the same view as above, seen in the present day. Many of the structures immediately on Market Square have changed little while extensive building and refurbishing is evident along Caroline Street. (JFC.)

Another relic of Fredericksburg's Colonial heritage is the revered home of Mary Washington, the mother of George Washington. This early postcard, published by Robert A. Kishpaugh shows the Charles Street residence with a Victorian-era porch attached. (JFC.)

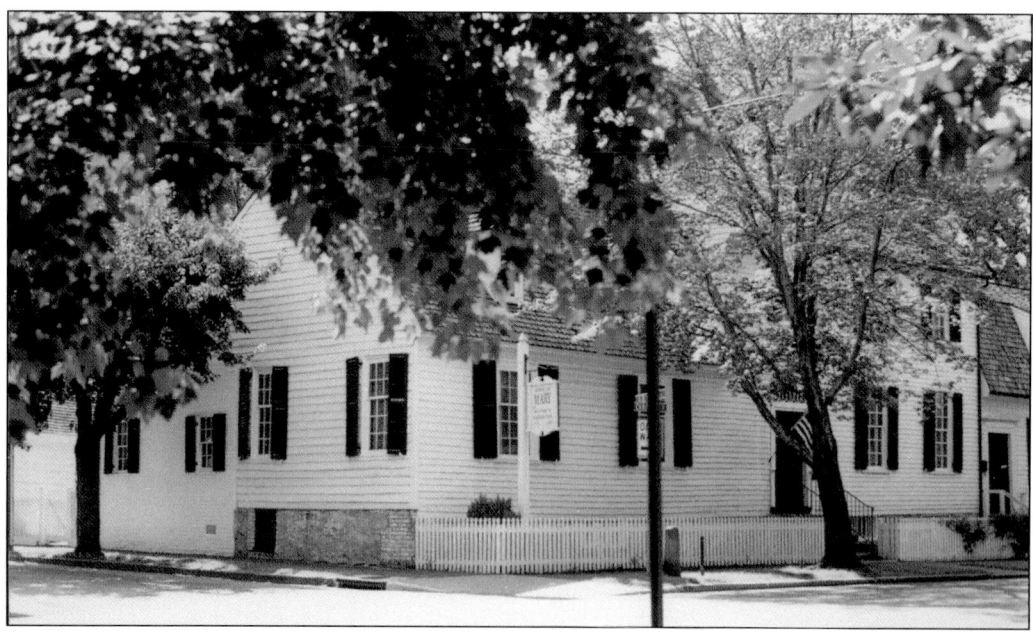
The Mary Washington home is another project of the APVA and is restored to its 18th-century appearance. She lived here from 1772 until her death in 1789. It was at this home that our first President bade farewell to his mother before his inauguration on March 12, 1789. It would be their last meeting. (JFC.)

Two

WAR COMES TO TOWN

The fact that Fredericksburg was equidistant from two opposing capitols, roughly 50 miles either way, was a reliable indicator that the irrepressible conflict would tear at its heart. As early as the spring of 1862 it became apparent to many of the town's 5,000 or so inhabitants that it would be in their best interest to move out of potential harm's way.

Confederate military forces destroyed all the bridges leading into town and then withdrew. On May 23, Union President Abraham Lincoln visited his army who had easily entered the town earlier that month. There he would make brief remarks to a gathering of beleaguered citizens from the steps of the Farmer's Bank of Virginia.

By the end of August, the Union forces under Irvin McDowell would leave, and shortly thereafter, the Southerners would return. After the lackluster performance of George McClellan following the battle at Antietam, Maryland, Ambrose Burnside was placed in charge of the Federal Army of the Potomac. Due to complications beyond his control, Burnside's vision of crossing the Rappahannock unopposed and moving on Richmond became an unrealized hope. What came to pass was a fiasco wherein the town of Fredericksburg would pay dearly.

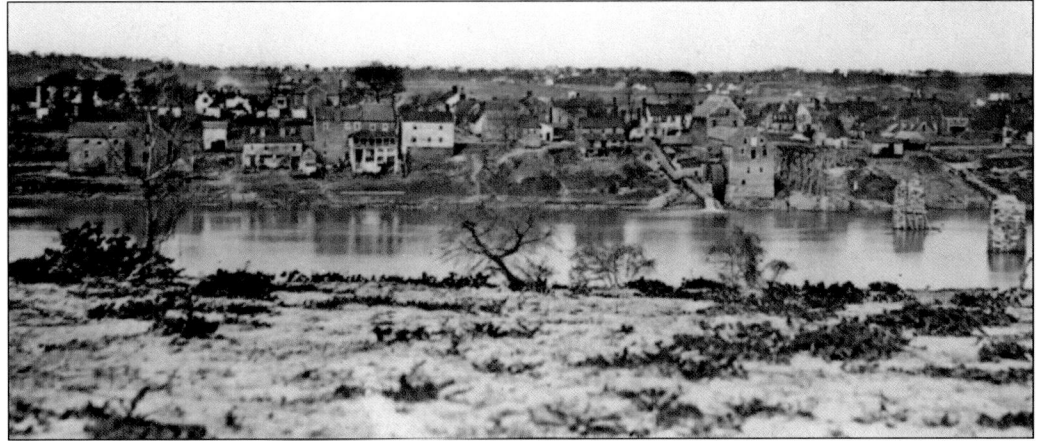

Seen in this 1863 view from the Stafford Heights, the town is virtually abandoned. To the right are the abutments of the Richmond, Fredericksburg, and Potomac Railroad Bridge, destroyed as an impediment to an easy Union occupation. Across the rear horizon looms Willis Hill and Marye's Heights, the position the Confederates assumed during the December 1862 ordeal. (NPS.)

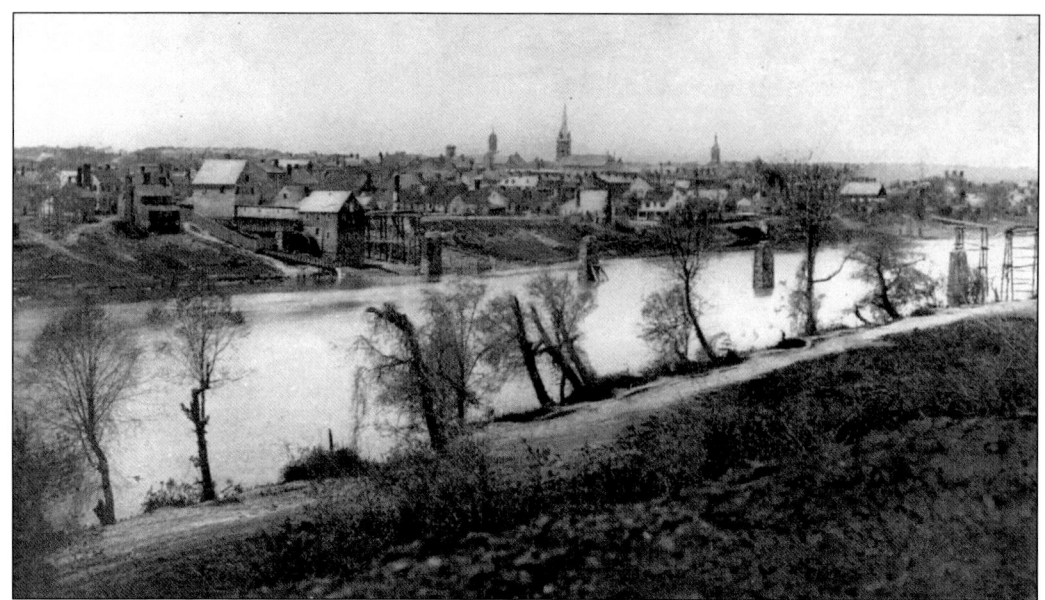

Here, another view of the town looks northward. The three spires stand defiantly against the sky. Along the Fredericksburg shore, Confederate forces had established their first defensive line. When Union troops attempted to bridge the river, a strong opposition took a murderous toll on engineers constructing the pontoons. As retaliation, Union gunners began to shell the town hoping to dislodge snipers. (NPS.)

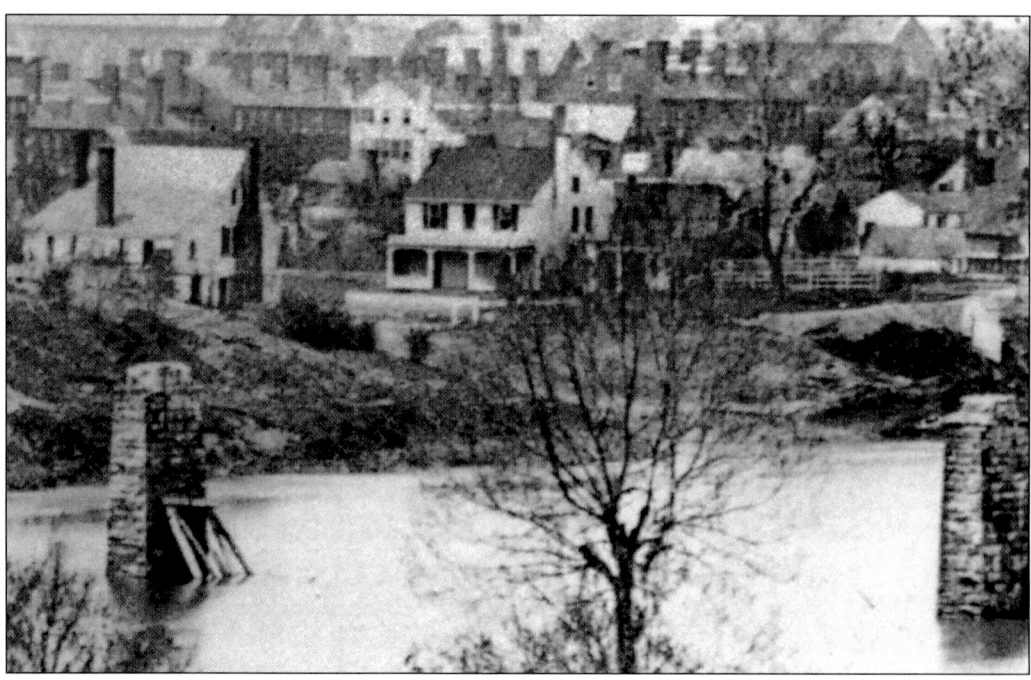

An enlarged detail of the above photo reveals homes along Sophia Street, as well as a section of entrenchments on the edge of the river at right. (JFC.)

A fascinating and wonderfully detailed photograph by A.J. Russell looks across the destroyed railroad bridge. Gathering on the opposite end are Confederate soldiers who had their curiosity aroused by the camera's presence. Immediately to the left of the bridge is the Marye's Mill, constructed in 1860 and powered by the Fredericksburg Water Power Company. (NPS.)

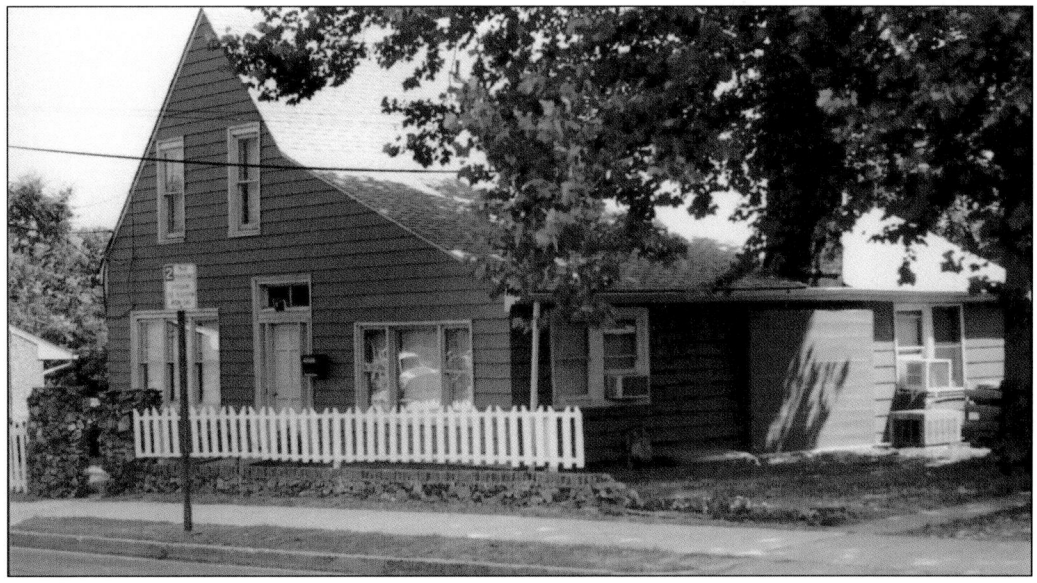

This house, seen today at 523 Sophia Street, is the same house seen at far left in the enlargement from the panorama. (JFC.)

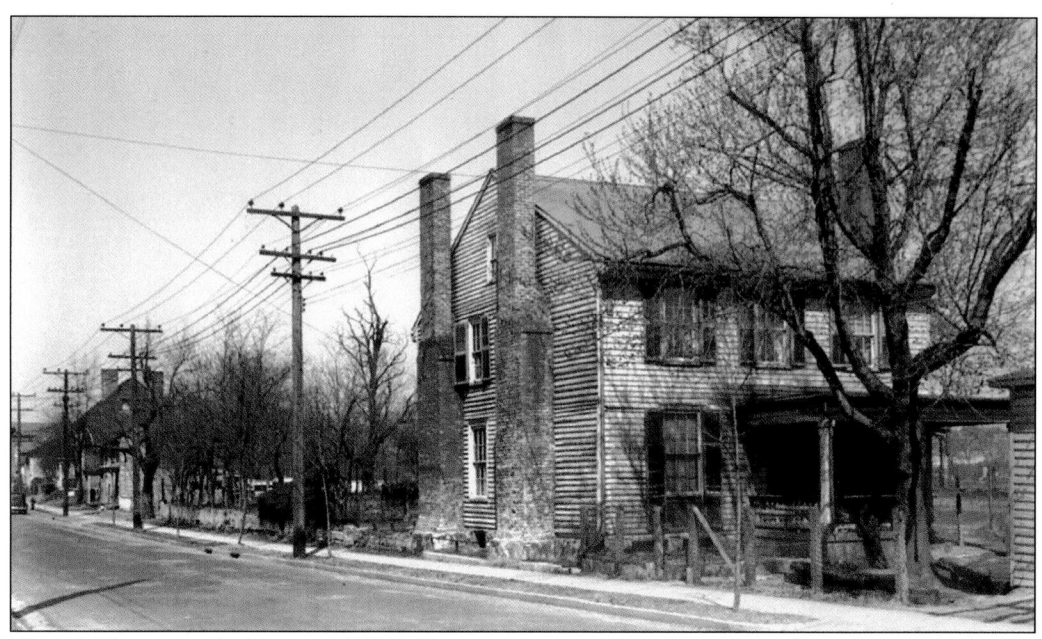

This 1930s view of what was 607 Sophia Street was taken as part of the Historic American Buildings Survey, a project designed to put unemployed architects to work during the Depression. The object was to document America's "antique" buildings. It is due to this effort, which later became a permanent program of the National Park Service, that we have documentation of many buildings now gone. This house can also be seen in the middle of the enlargement on page 22. The location today contains virtually none of its original features save for the Shiloh Baptist Church at the far left corner. (above, LC; below, JFC.)

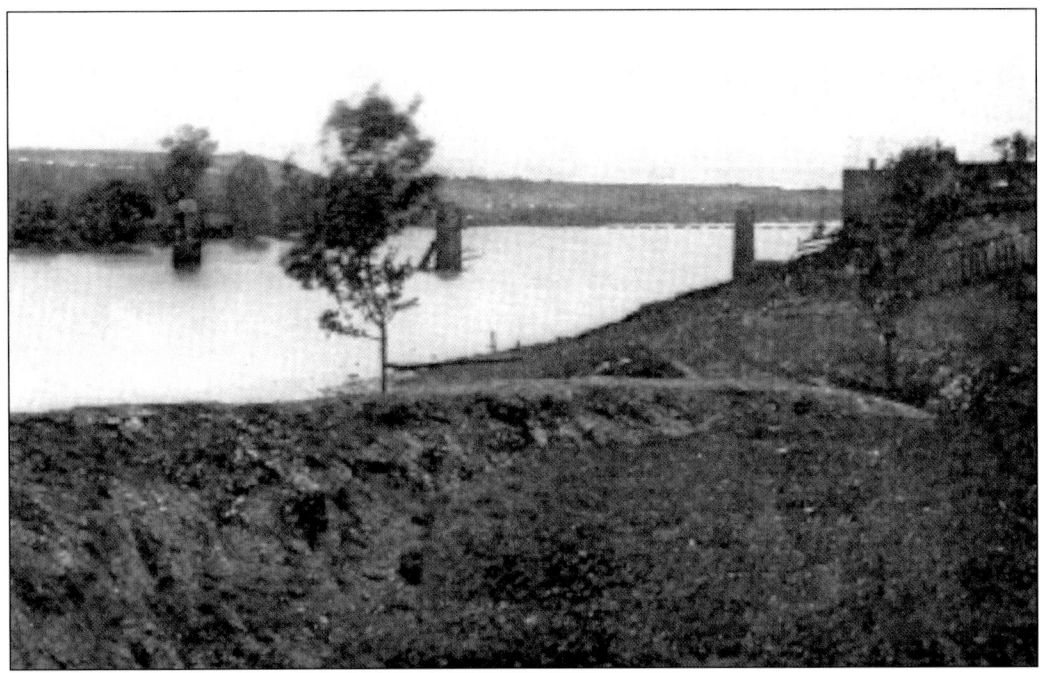

In this war-era photograph taken from Miller's Photographic History of the Civil War, an abandoned Confederate trench line is in the immediate foreground. Marye's Mill is at right and the destroyed railroad bridge silhouettes against the Stafford shore where Federal supply wagons cross the pontoon bridge. The same location today is the back end of a parking lot on Sophia Street and was part of the yard for the home on the previous page. (JFC.)

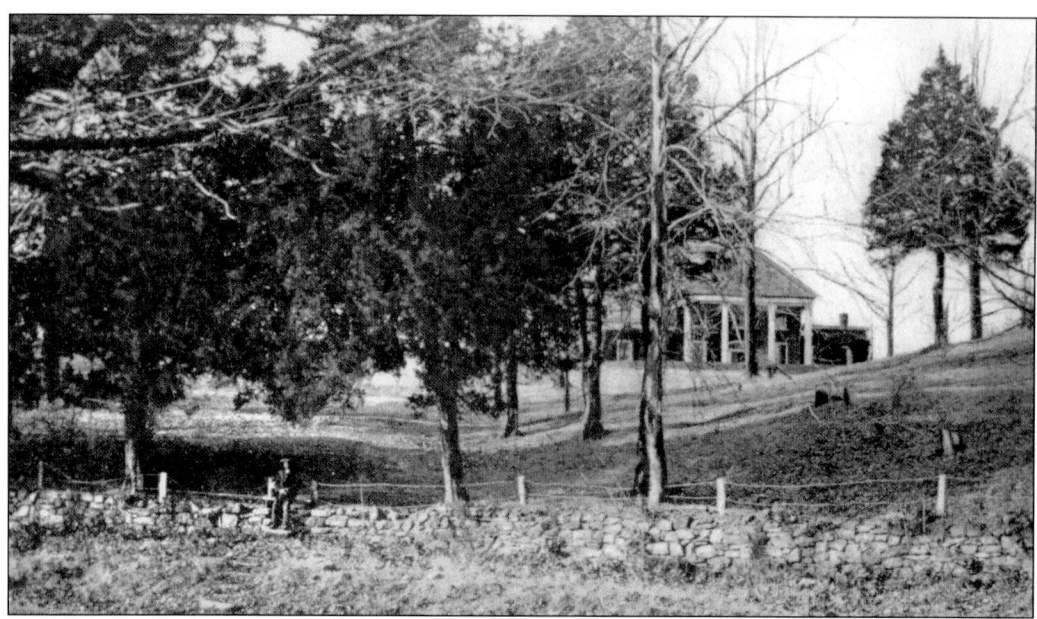

West of town is Brompton, which was built around 1824. This imposing structure was the home of attorney and politician John Lawrence Marye, whose name also graced the mill next to the railroad bridge. John L. Marye Jr. was a pre-war mayor of Fredericksburg, and in 1859 he was the president of the Water Power Company. The Maryes apparently wielded a lot of power in town and the Commonwealth. John Sr. died in 1902 and John Jr. died in 1918. After the war, Capt. Maurice B. Rowe, a war veteran, dealer in meat, and city councilman, bought Brompton and resided there until his death in 1925. Rowe was one of Fredericksburg's most active citizens with his name attached to a plethora of civic organizations and committees. Brompton is today the residence of the president of Mary Washington College. (JFC.)

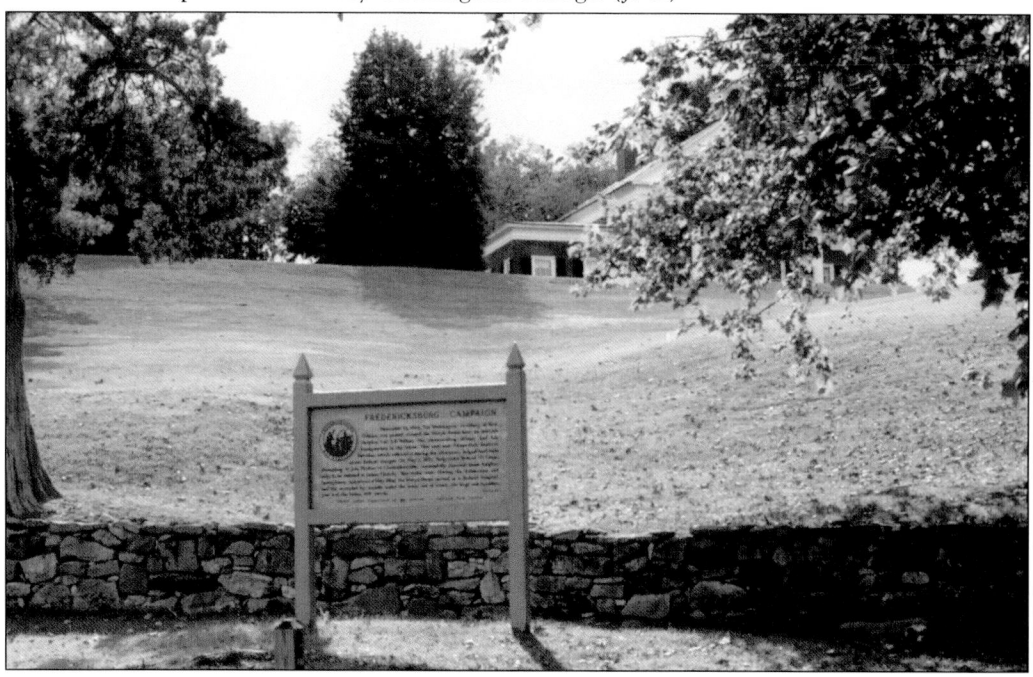

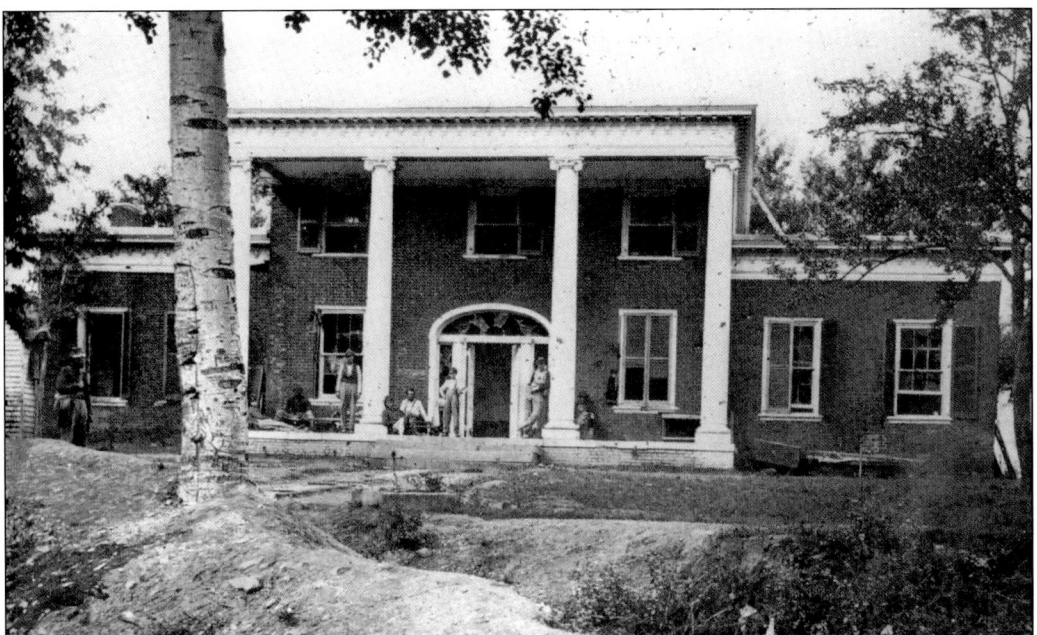

When this photograph was taken in 1864, Brompton had withstood the worst of two major military engagements. Its scarred exterior attests to the ferocity of battle. On the porch are wounded Union soldiers and hospital stewards. The wounded were pouring in from the battlefields in Spotsylvania County. (LC.)

In the modern view from atop the hill, one can see the advantage of holding this high ground. The infamous Sunken Road runs through the center of the picture, bordered by the stone wall. At far right is the Innis House, another bullet-riddled witness to the battles. Along this line was Ransom's Division of North Carolina infantry who leveled their muskets at repeated Union assaults. (JFC.)

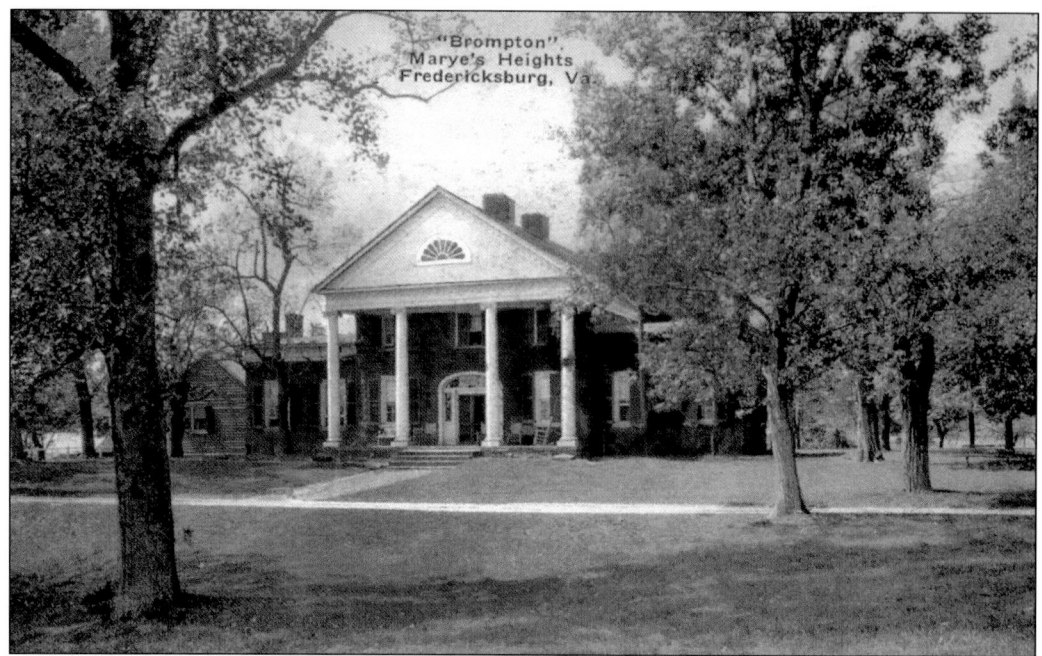

Another fine postcard by W.L. Bond shows Brompton with its large, post-war pediment. The wooden kitchen on the left is one of several outbuildings that survive intact today. The grounds and garden are finely maintained. (JFC.)

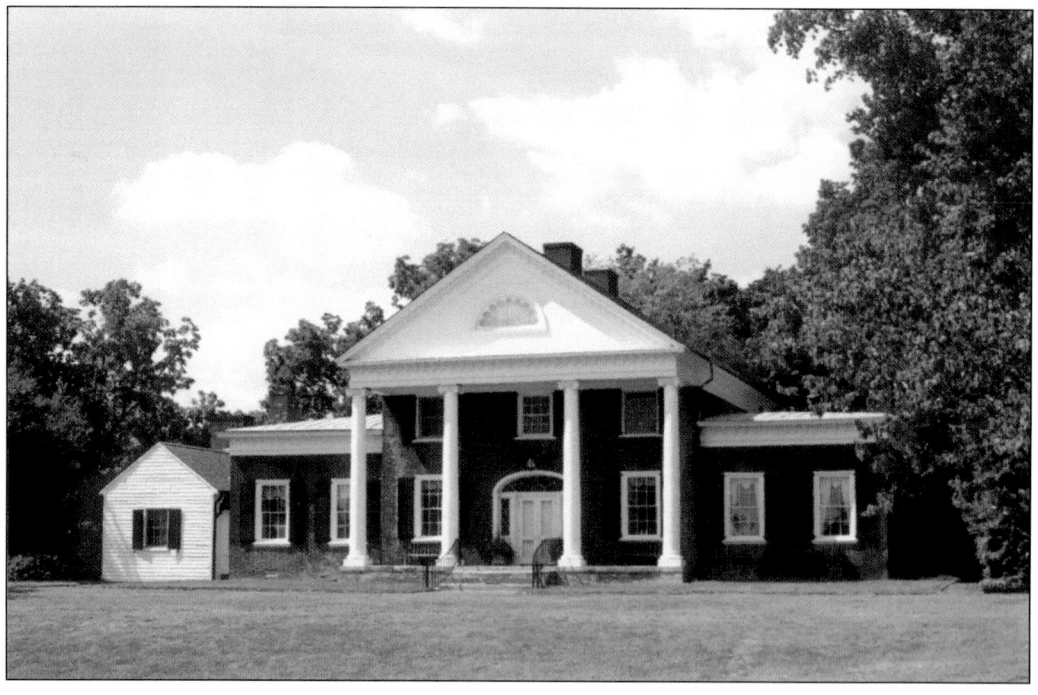

At right are some of the most tangible scars of war that remain on the house today. These pockmarks were created by small arms fire and artillery shell fragments. They cover most of the wall. Below is a section of entrenchments that were left as they were and allowed to soften with the years. These earthworks overlook Hanover Street. (JFC.)

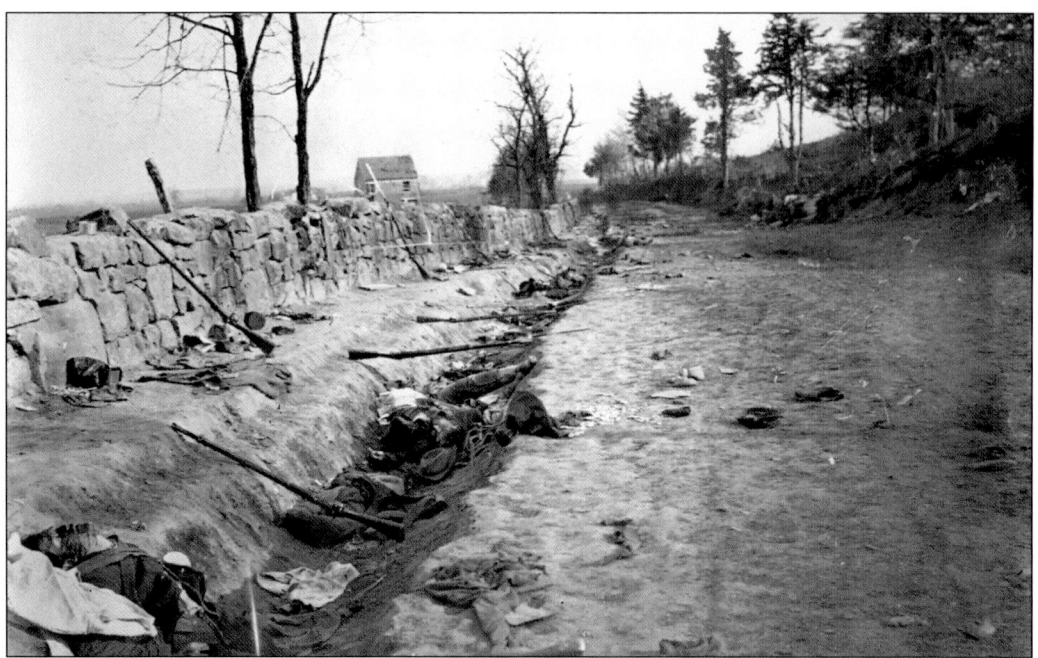

This is the shocking face of war as photographed by Captain Russell, who recorded this scene shortly after the guns fell silent on Sunday afternoon, May 3, 1863. Union forces did that spring what they were not able to do five months earlier and captured the heights in a phase of the Chancellorsville Campaign. Below is a modern-day view of approximately the same spot. This section of the Sunken Road has been acquired by the National Park Service and will eventually be closed to motor vehicles. Archaeological surveys will help to restore the road to its wartime grade. (above, LC; below, JFC.)

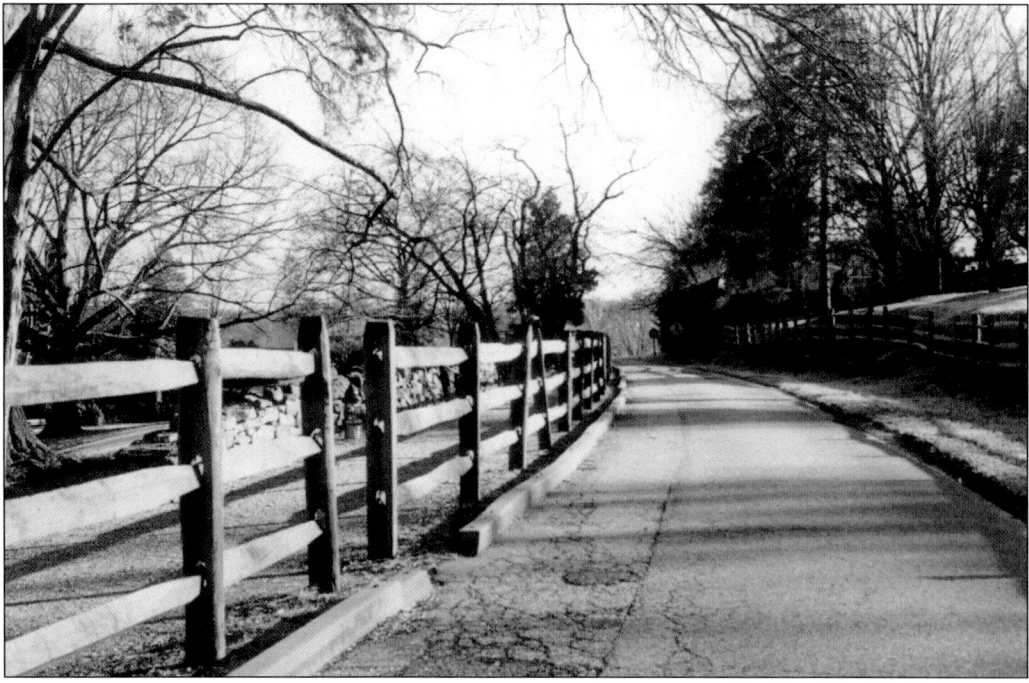

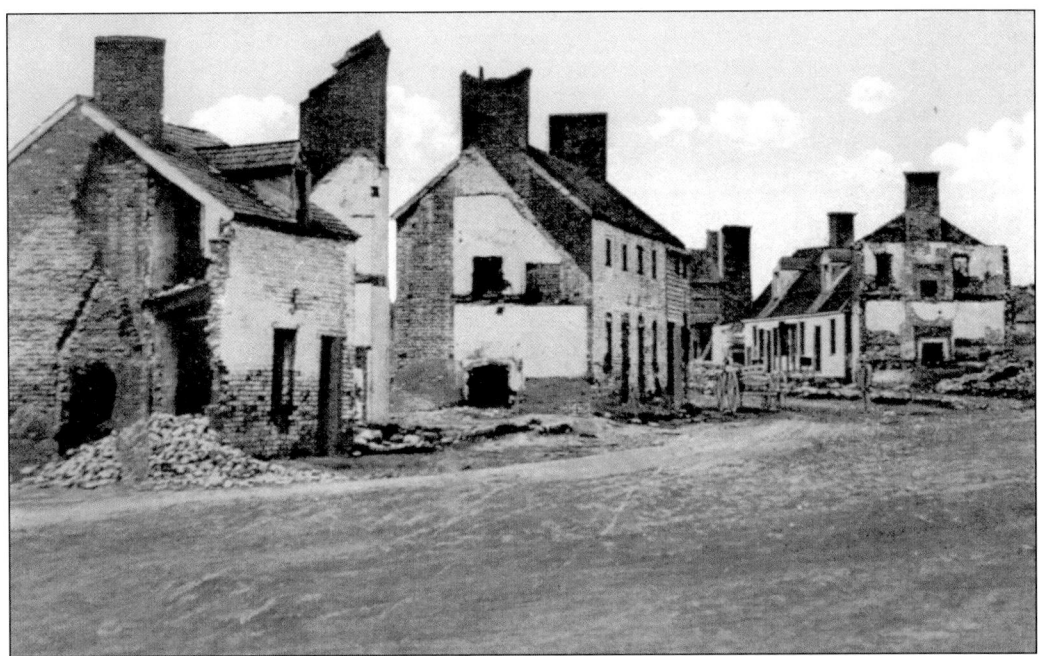

These wrecked Colonial structures at the intersection of George and Hanover Streets show the destruction wrought by artillery of both sides during the battles of 1862 and 1863. This image was made by one of Mathew Brady's photographers around May 19, 1864. In the modern version below, it is evident that none of the older structures have been rebuilt. Behind the fence at left is the athletic field for the former Maury School. The community uses the field for outdoor concerts and activities, a pleasant contrast to the hostility that crossed this ground before. (JFC.)

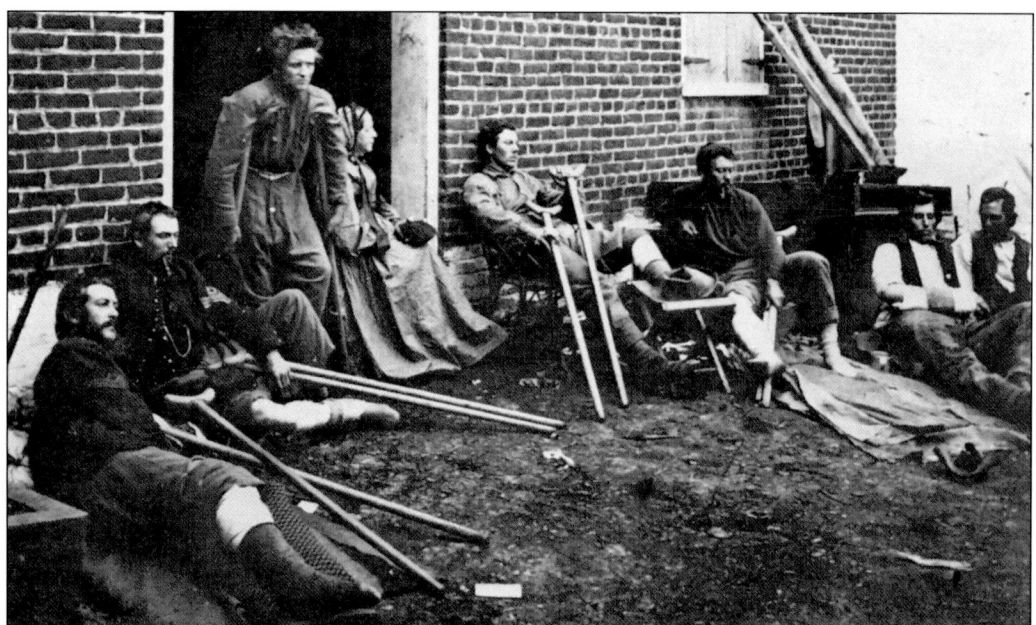

The spring campaign of 1864 was unrelenting. The Spotsylvania countryside was littered with the dead and dying of two armies. All across town, warehouses, churches, and many private homes were commandeered to serve as hospitals for the thousands of wounded who were being sent daily to Fredericksburg. This photograph taken on May 20 shows the rear of a warehouse at 1011 Charles Street. Men of the Federal VI Corps recuperate in the open air. The building still stands today. Access to the rear of the structure is very limited. Most of the open yard from which the war-era photo was taken has been built on. A modern version cannot be reproduced from the same angle. Here, we are looking directly south from the opposite angle of the original. The building is currently occupied by a law firm. (above, LC; below, JFC.)

This is a close-up of the warehouse doorway. The wood framework is original. Modern French doors have been installed. (JFC.)

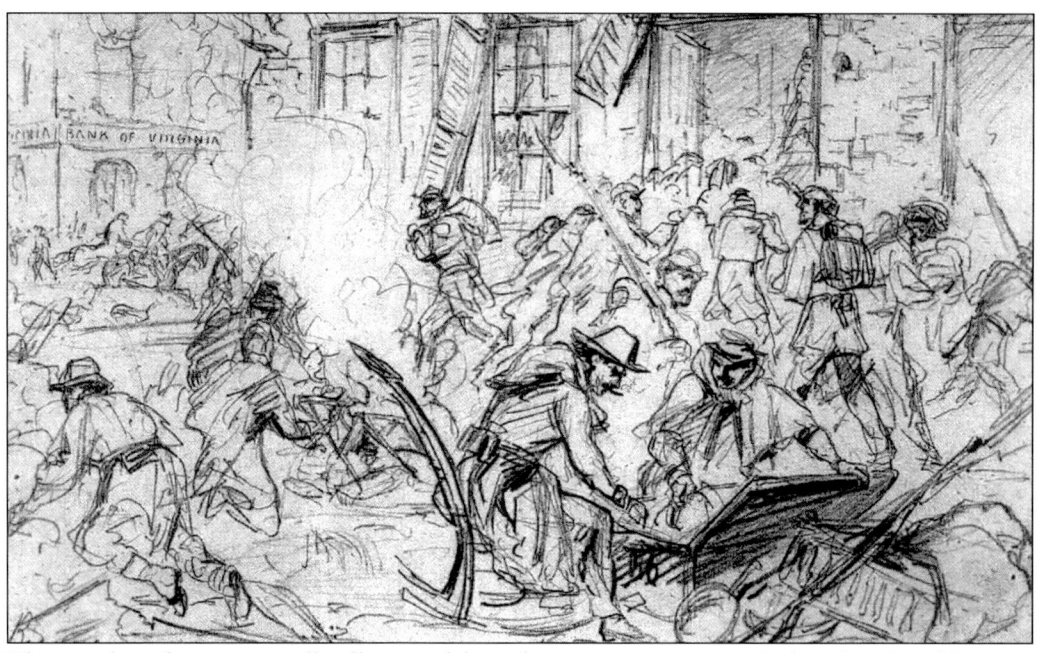

The cruelty of war is vividly illustrated here by newspaper artist Arthur Lumley. His own words described this scene as the "Sacking of Fredericksburg." On the evening of December 12, after a hard-fought entrance to the town, Union soldiers wantonly looted the stores and homes of the business district and beyond. With shameless abandon, furniture and all manner of personal possessions were brought out into the streets and pilfered. Many exquisite items were stolen or smashed in wild abandon. This was not official military policy, but the crime went largely unchecked. Today, the same intersection, Caroline and William Streets, is the heart of the merchant once again. Where the Bank of Virginia was destroyed, an antique mall now flourishes. (above, LC; below, JFC.)

Three

SPOTSYLVANIA COURT HOUSE

For anxious inhabitants of Fredericksburg, an exodus began when word of the Federal approach reached town. The vast, pastoral countryside of Spotsylvania seemed to offer the necessary seclusion for some of the displaced. How heartrending for families to leave behind their homes to a questionable fate.

In late April 1863, Myer purchased a 400-acre farm just below the Ni River and about a mile and a half east of the Spotsylvania Court House. The newfound solace would not last long. The next spring, hostilities erupted 15 miles northwest of the farm. John Henry Myer would be impressed into service in the Confederate army, leaving his wife and little ones to fend for themselves. Within two weeks, the battle had shifted to their farm, and by May 15, the Myer home and dependencies were burned to the ground.

A post-war memoir by a soldier from Georgia gives insight into the plight of area civilians. "As we were going up we met 500 or more women and children, some of the women with two little babies in their arms, other children holding to their mother's dresses, crying and screaming for their lives, the shells flying. There was a large gully on the south side of the road, and some of the boys told the women to get in the gully. They did so, and I never saw them any more. I suppose some of them got hurt."

Shown here is the intersection of Court House Road and Brock Road. In this early 20th-century view, the Spotsylvania Court House itself is nestled amongst the trees at left, its lawn enclosed by a whitewashed brick wall. Barely visible beyond it is the jail. Straight ahead is the large Sanford's Tavern, watering hole and overnight accommodations for those with county business, and travelers on their way to Richmond or Orange. (JFC.)

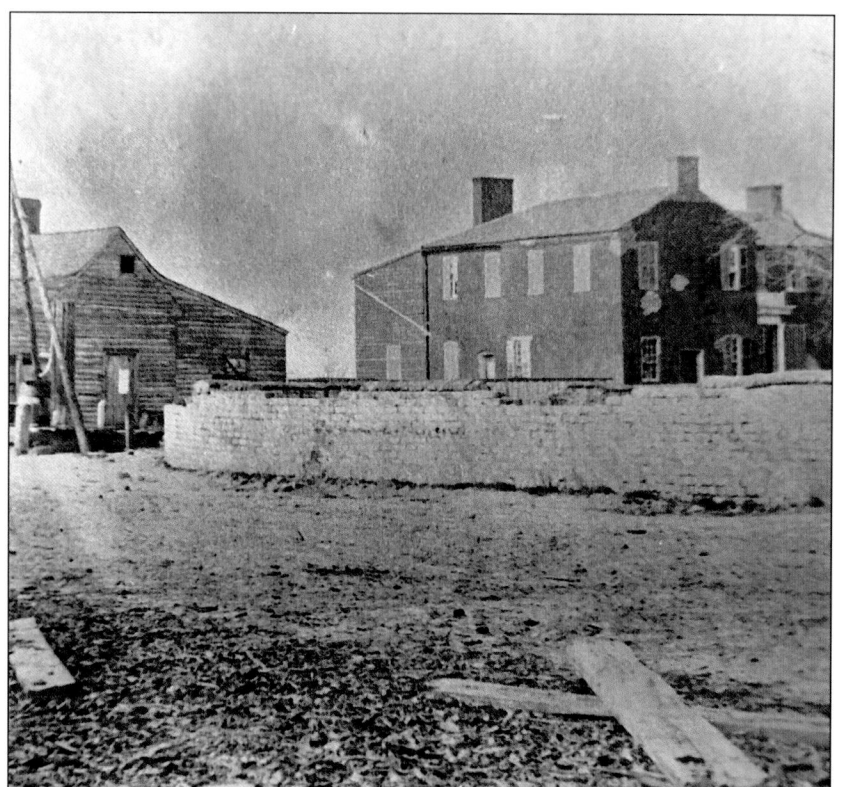

There was nothing around the crossroads in 1864 that would have foretold the events of May 8 through May 21. From the western wilderness of the county, the Brock Road would be the Federal army's avenue of approach to Richmond. Confederate cavalry constructed log barricades that served as a formidable obstacle across the road. General Grant's legions would not march past these buildings. Instead, after two weeks of frustration, he would have his army sidestep an impregnable Confederate defensive line and continue to maneuver its way south. This view looks north at the intersection where a large brick home and a stable are seen beyond the wall around the courthouse. To the left is the village well, from which the wounded Stonewall Jackson was refreshed the year before while en route to Guinea Station. Today, everything has changed. (above, NPS; right, JFC.)

36

This view, taken shortly after the war, looks once again toward the Spotswood Hotel. Visible now at right, is the large brick house seen on the previous page. It was built in the 1850s, and at the time of the battle, was owned by Joseph Sanford, the proprietor of the hotel. In this modern view, the courthouse is obstructed by trees and newer county office buildings. The old hotel, now occupied by the law offices of Jarrell, Hicks, and Sasser, still dominates the intersection. (above, NPS; below, JFC.)

A post-war photograph of Sanford's Tavern shows a gathering of civilians posing on the front steps. A fire gutted the interior of the building just into the 20th century, but the interior was rebuilt and the hotel opened again. The only significant changes to the outside appearance seen today are the modifications to the roof line, including an additional chimney and a dormer. (above, NPS; below, JFC.)

This image of the county jail was made in the 1930s as part of the Historical American Buildings Survey, conducted by the United States government. The jail was completed by 1856 in a contract awarded to Joseph Sanford. Sanford was the local entrepreneur, to say the least, and owned considerable parcels of land around the courthouse. The jail continued to be used in its intended capacity until 1943. The modern view of the jail shows drastic changes to the exterior. At one point, the bottom floor walls had to be stabilized, thus the additional thickness seen here. The building was used for various purposes, including an office for the phone company. Today it is being restored by Spotsylvania Preservation Foundation, Inc. (above, LC; below, JFC.)

Spotsylvania resident George William Clark and his family sit for a portrait sometime between 1881 and 1887. At the age of 17, Clark enlisted in the Fredericksburg Artillery on May 1, 1864. Within the week, the war had moved to the familiar soil of the Court House. Clark's parents were neighbors to the Myer family farm and shared equal hardships. From left to right, members of the Clark family are Lucy, George W., Mortimer, Esther, Amanda, baby Nellie, Alice, and Willie. (AD.)

While serving on a gun crew with the Fredericksburg Artillery, Clark witnessed the destruction of his family home. He was unable to do anything to save it. This photo shows Clark with his cousin, Arlyn Height. Clark worked hard as a farmer after the war and, just like John Henry Myer, took time to be active in the community. He served on the Spotsylvania County Board of Supervisors and the County School Board. He died in 1925. (AD.)

Sitting in the no-man's land between the lines was the Dabney House, residence of the wartime clerk of court, Robert C. Dabney. The building survived the battle, and has long been the home of the Alrich family. (JFC.)

Just south of the Ni River stands Whig Hill, most likely built around the 1840s. During the battle, it was the home of the Francis C. Beverly family and was used after May 14, 1864 by Gen. Gouverneur K. Warren and his staff. From this home, the Myer farm was visible one mile to the east. Union soldiers began their assault of Myer's Hill from this property. (LC.)

This is Whig Hill as seen from Court House Road in the 1930s. The sunken driveway was used as a ready-made trench for soldiers of the 20th Michigan Regiment during an early phase of the Spotsylvania battle. The view of Whig Hill is today obscured by a good number of trees. Widening of Court House Road has necessitated a modification of the old driveway. This modern view is from a slightly different angle to allow the best visibility of the house. A pond has been created in the middle of the property as well. (above, LC; below, JFC.)

This is a modern-day view of Court House Road taken from the position of the Fredericksburg Artillery, George W. Clark's unit. On the distant horizon stood the Federal line. The wartime landscape was not as heavily covered with trees. The illustration below was made from a sketch drawn by newspaper artist Alfred R. Waud from the left flank of the Union V Corps around May 18, 1864. At far right can be seen the distinct L shape of the brick home owned by Joseph Sanford, across from the courthouse. (JFC.)

This is Sanford's house as it appeared in the 1920s. A covered porch had been added to the front. At the time of this photograph, it was the residence of S.P. Powell, the Commonwealth Attorney for Spotsylvania County. The photo at bottom should be compared to the one on the facing page. On Sunday evening, July 13, 1930, the Powell home was set afire by an arsonist. The blaze also consumed the neighboring former store of G.W. Perry. The site of the house is now occupied by the Human Resource Offices of Spotsylvania County Government. The photo at right shows the ruins of the Powell house as seen in the 1930s by the Historical American Buildings Survey. (above, CPM; left, JFC; right, LC.)

44

Another building lost to posterity is that of the Harrison Farm on the Spotsylvania Courthouse Battlefield, maintained by the National Park Service. It was the home of Edgar W. Harrison and his wife Ann. It was not a large farm and considered a modest dwelling; Harrison did, however, own at least 11 slaves according to the 1860 census. One of his chattel was 35-year-old Rose Smith and her four children. Her son, Joseph Walker, was nine at the time of the battle but wrote a memoir in 1940 in which he vividly described the engagement around his master's home. The photo above shows the Harrison house site today. At left is a portrait of Joseph Walker, who grew up to become a model citizen of the African-American community in Fredericksburg. Walker Grant Middle School is named after him. (above, JFC; left, FS.)

Joseph Walker's great nephew, Frederick Silver of Fort Washington, Maryland, surveys the Spotsylvania property that Walker bought for his mother, Rose, in 1873. On this property, he built a cabin for her near the Po River. Walker worked as Sexton of St. George's Church and was Senior Deacon of Shiloh Baptist, New Site. He was known by his friends for his "unfailing politeness and generosity." He died in Fredericksburg in 1943. (JFC.)

Shown here is the harvest of battle from the evening of May 19, 1864. This image was one of many taken the next morning on the farm of Susan Alsop by Timothy O'Sullivan. The grim carnage all across Spotsylvania County throughout the war totaled over 100,000 killed and wounded. Spotsylvania witnessed more bloodshed than any other county during the war. (LC.)

For years after the conflict, veterans of both armies returned on numerous occasions to walk the fields and contemplate the national tragedy that defined their youth. Here, a group of Union veterans poses for a souvenir photo on the now-peaceful lawn of Spotsylvania Court-House. The year was 1887. (NPS.)

Four

THE PHOENIX RISES

With the end of the Civil War came the undaunted task of returning a war-torn town to its previous luster. The job would not be easy as so much had been destroyed or seriously damaged throughout the four-year struggle. Full realization was not achieved until the turn of the century, but life would obtain a sense of normalcy as the town continued to grow, stretching over the former battlefield landscape. The town became a city in 1879.

John Henry Myer stepped forward to assist in the process, serving on the Common Council for 30 years. Personally, Myer would be one of the most fortunate, attaining a financial success that would provide for his family years after he left this earth.

Thirty-five years after the guns fell silent, the town would return to near its pre-war population. New businesses made Fredericksburg their home and many improvements to infrastructure and services were made. Accommodations such as the Hotel Maury provided for visitors to the region's battlefields including veterans of the conflict who erected monuments and marked former scenes of glory.

Caroline Street sprang back from the ashes to provide over a mile of shops, hotels, and fine homes. This is the 800 block looking south. This 1906 view was published by W.E. Lang, a Fredericksburg merchant. The tallest structure on the left is the Pythian Building, home of Hopkins Furniture Company and the Knights of Pythias Meeting Hall upstairs. At right is James T. Lowery's dry good store at 818. (JFC.)

This is the City Hall on Princess Anne Street as it appeared in about 1920. Upstairs, the Common Council worked long hours to facilitate the needs of the town. At left is the Bradford Building, destroyed by fire in the 1960s. (JFC.)

The City Hall has been restored and is now the home of the Fredericksburg Area Museum and Cultural Center. Visitors can view the Council Chamber and see numerous permanent and changing exhibits though out the year. The current City Hall is two blocks south. (JFC.)

Councilman John Henry Myer is pictured sometime before 1876. A decade or more since the trauma of the Civil War, Myer was more determined than ever to provide for his family and community. His pre-war bakery flourished during Reconstruction and he collaborated with fellow immigrant Frederick Brulle to build and operate a large flourmill in 1868. (AL.)

This is the Germania Flour Mill as seen in an 1874 newspaper advertisement. A massive four-story structure on upper Caroline, known also as Main Street, Myer and Brulle produced a variety of award-winning products into the next century.

The mill accidentally caught fire in 1876 but was immediately rebuilt, eventually converting from millstones to a higher-production roller system. Output rose to 100 barrels per day. During the conflagration, Myer was severely burned on his arms and face. Today, the mill is again a ruin. (JFC.)

Here, at 317 Commerce Street, known also as William Street, is the office and warehouse of Myer and Brulle. Standing just to the left of the middle door is John Henry Myer in the derby hat. Myer is sporting a beard, which he grew to conceal the burns on his face. (AL.)

Somewhat altered in appearance and partially concealed by a tree, the building continues to be used today as retail and office space for a variety of businesses. The right-hand doorway seen in the older photo remains today, but the middle doorway has been altered and is now a window. The viewer can also note that William Street has been lowered during modifications to the city sewer system, thus two steps lead to the right-hand door. (JFC.)

This is the 800 block of Main Street looking north with a good view of the Enterprise building on the left-hand corner. This was used for office and apartment space. For a time the United States Post Office was on the left-hand, bottom floor as it was when this card was mailed in 1907. The street seems filled with midday activity. (JFC.)

Today, Caroline Street is a tourist mecca with antique stores, restaurants, and art galleries. In the 1920s, the Enterprise Building became the Athens Hotel. It has since reverted back to apartments, most commonly occupied by college students. (JFC.)

This is Caroline Street looking south once again, only this time it is the 900 block near the intersection with William Street. Printer and stationer Robert Kishpaugh published this card. His storefront can be seen at extreme right. Next door to him is the Boston Variety Store. Kishpaugh started his own business at the age of 15 in 1894. He was born in 1879, the son of a Confederate war veteran, Alfred Kishpaugh, who had served in the 9th Virginia Cavalry and had seen action on the Myer farm on May 14, 1864. This block has had some of the most drastic alterations in the past 100 years. Mid–20th century "modernization" inspired many property owners to deface the older facades of these buildings as can be seen in the current view below. Several other structures have been destroyed by fire. (JFC.)

One block north, at the corner of Amelia Street, is the "Hugh Mercer" Apothecary Shop. In the 1920s it was restored by the Citizens Guild of George Washington's Hometown, Inc., and associated with Dr. Hugh Mercer, a friend of Washington. Mercer died at the battle of Princeton, New Jersey on January 3, 1777. Dendrochronology tests, conducted in 2000, determined that the shop was constructed in either 1771 or 1772. Despite its age, it is today acknowledged that Mercer's shop was elsewhere on the block but long destroyed. This early 20th-century card shows the shop before restoration and before the expansion of the Baptist Church on the western corner of the block. To the left is another Colonial-era home that met its fate in 1937 when a movie theatre was constructed on the site. (JFC.)

Another fine structure that met the demolition crew in the 1950s was the Opera House on the northeast corner of the intersection of William and Caroline Streets. Built years after the Civil War on the land formerly occupied by the Bank of Virginia, the Opera House entertained and delighted Fredericksburg from 1884. Across the street is the famous Bond Drug Store. Dr. William L. Bond purchased the former Hall's Apothecary in 1907. This had been known as the oldest drug store in America, beginning operation at this location in 1791 by Elisha Hall. Bond also published and sold postcards of Fredericksburg, of which this is an example. Oftentimes, Bond would stand somewhere in the scene. On the left street corner, he appears to have been superimposed in the picture. (JFC.)

This is a 1920s view looking to the west on the 200 block of William Street, from the same intersection with Bond's now on the right. Halfway up this block on the left is the former Myer home and business address of 212. The tallest building on the left is the Bradford Building. This card was published by the firm of Louis Kaufmann and Sons of Baltimore, Maryland. Little has changed in the modern view below except for the addition of pear trees. Many of the larger retailers, responsible for modifying or destroying the Colonial and Victorian-era buildings, have left downtown for the suburbs four miles or so to the west. The old business district continues however to be a major tourist draw and a means of escape from the day to day congestion of Northern Virginia and Washington, D.C. (JFC.)

This card, posted March 31, 1909, shows a tree-lined Princess Anne Street with the spire of the Circuit Court building in the center and St. George's at left. The gothic structure at right is actually two buildings, part of the modified Masonic Lodge and to its left, the town firehouse. The circuit court was designed by James Renwick who is most noted as architect for the Smithsonian Institute "castle" building. The court was constructed in 1852 and served during Union occupation as a hospital, jail, and signal station. As seen in the modern view below, the firehouse tower has been removed and the front of the Masonic Lodge has been restored to its original appearance. (JFC.)

W.L. Bond walks in front of St. Mary's of the Immaculate Conception at 724 Princess Anne Street. The structure was completed on March 20, 1859. Of note is the frame bell tower, which was later eliminated with the addition of one to the southwest corner of the church. The parish home is at left. At right is a large house built about 1786 by Charles Yates. When this image was made, it was the home of Miss Sallie Innis Forbes. It has since been demolished and the lot remains vacant. During the early morning hours of December 13, 1862, a brigade of the Federal II Corps lined this block of Princess Anne in preparation for the ill-fated assault of Marye's Heights. The church was later used as a hospital and, at one time, as a stable by the military. St. Mary's congregation has been relocated to a modern facility on William Street extended. The old church building now serves as apartments and law offices. (JFC.)

A Kishpaugh postcard cancelled in December 1919 shows the intersection of Princess Anne and Hanover Streets, looking south. At left is the Masonic Lodge with the since-removed, extended facade. On the next corner is the United States Post Office completed in 1910. That building has since been converted into the current city hall. Across the street at right is Forbes House and beyond it St. Mary's. In the modern view below, we see the now-exposed original facade of the Masonic Lodge. Just out of view at left is the firehouse, which is now an antique shop. The city hall is obscured by the trees. (JFC.)

Another Kishpaugh card from the 1920s shows the full front of the Fredericksburg Masonic Lodge No. 4. The one-room thick addition to the front is easily distinguishable from the slope of the roofline. Around the time of this image, the "Continental Tea Shoppe" was operated in the front of the lodge. Princess Anne had become part of the U.S. Route One corridor, which served Virginia as its principle north/south highway. In the early 1960s, the lodge was somewhat restored to its appearance during the days of George Washington. Here on November 4, 1752, the father of our country became a Mason. The lodge continues to meet here and maintains a museum of artifacts open by appointment only. John Henry Myer was also a Mason at this lodge and one of the oldest members at his death. (JFC.)

62

This is the old passenger depot for the Richmond, Fredericksburg, and Potomac Railroad, built in 1887. It served in this capacity until the fall of 1910 when a new brick depot was completed across the tracks. The frame structure at left is the Hotel Marshall. Below, the same view is quite a contrast. The rails that ran across the foreground were realigned and elevated with completion of the project on May 1, 1927. In the right background is the landmark Purina grain tower, built in 1919 for the Young-Sweetser Company. The grain tower is currently undergoing restoration. (JFC.)

In 1910, a modern train station was opened on Prussia Street (now Lafayette Boulevard) between Caroline and Princess Anne. Many other improvements were being made around this time to the rail system. As traffic increased on the RF&P, the entire railroad was double tracked with the exception of the section that ran through Fredericksburg and over the river into Stafford County. In this wonderful card, a train is pulling up to the station. At far right can be seen the large peaked roof of the old Marye's Mill, which still stood alongside the bridge. In the modern view below where Princess Anne crosses, we are struck by the immense changes. The station was later expanded and the tracks elevated. The station is now home of Claiborne's Restaurant. (JFC.)

The most striking thing about this c. 1907 view from Stafford is the heavy vegetation that has taken over the banks of both sides of the river. In approximately 40 years, the Marye's Mill was no longer in operation and overgrown. The wooden warehouse on Sophia Street was being used as mattress storage for the Virginia Excelsior Company. A large water tank for the RF&P looms overhead. (JFC.)

Looking north from the docks, a train roars toward town across the single steel span built in 1889. In the distance is the "Free Bridge," which carried vehicular traffic from William Street to Stafford. The open ground in the middle horizon is the Chatham Estate. (CM.)

These are two more views of the busy 1910 passenger station. The automobile had yet to make an impact on Fredericksburg. A horse-drawn carriage is awaiting an arrival. (CM.)

It has been argued that it was the introduction of the railroad to Fredericksburg in 1842 that led to the economic decline of the town. Fredericksburg was no longer an overnight stop between Washington and Richmond. The overland stage became a thing of the past.

66

This pre-1925 view shows the arrival of the automobile and with it, the even heavier traffic the RF&P would realize. Further expansion would be needed. In 1925, the railroad began to take bids on the future improvements. Marye's Mill, still seen at far right, would soon be leveled. (JFC.)

With the advent of the railroad, the Rappahannock was no longer a necessary means of mercantile transportation. Recreational and tourist boating took over. A line of steamers began to make a regular route to Baltimore and other destinations. On November 14, 1901, the steamer *Richmond* burned at the wharf. This card shows one of boats that cruised the river in the 1920s leaving the docks. (CM.)

The 1910 passenger station was expanded and the tracks elevated with completion of the project on May 1, 1927. Elevation was necessary for two reasons: first, to prevent delays due to crossings on the first four blocks of town; secondly, to prevent the possibility of flood damage as a previous bridge, built in 1882, had been lost. A double-track reinforced concrete bridge replaced the single-line steel bridge. Below is the station as it appears today. Commuter trains stop here daily. (JFC.)

This quaint scene from around 1905 is on the banks of the river just below the "Free Bridge" which replaced a toll bridge around 1887. (JFC.)

Today, the river is rarely at its old level. It is said that during the Colonial era it was twice as wide and deep. So much water is drawn off further upstream by the growing population of the surrounding area. The right bank seen here is actually Scott's Island. At one time in the early 20th century, an amusement park was operated on the island. (JFC.)

A rowboat named *Dixie* navigates the gentle river near Ferry Farm seen on the hill in the distance. This post card is dated 1905 and was published by the Rotograph Company. It is hard to visualize the chaos that once erupted on these shores with shots and shells screaming overhead. The birds-eye view below was mailed on November 19, 1907. It was taken from the heights near Chatham Manor. The foot of the Free Bridge spills into Stafford County. (JFC.)

Nearly 300 years had passed since Capt. John Smith made his voyage up the wild Rappahannock. The Native Americans had all been driven from the land, and the mighty forest ravaged. The primeval world was tamed. Fredericksburg, Virginia was now a city.

This card, published by Bond, was posted August 28, 1912. It shows a rare close-up of the Free Bridge, looking over to the Stafford side. Its modern equivalent view below was taken from approximately the same spot 90 years later. The four-lane "Chatham Bridge" was opened on August 16, 1941 to replace the highway bridge destroyed in the flood of 1937. Another flood would hit the town in October of 1942 with the river raised 45 feet, reaching Caroline Street. This was the highest recorded level for the Rappahannock. (JFC.)

This is a companion view of the river, looking north. It was taken from the middle of the Free Bridge showing low tide with the exposed sandy shore of Scott's Island in the bottom left. This card was mailed the same day as the one on the previous page. It is interesting what is written to the addressee in Fauquier, Virginia, "Cool here today No horses in this section at all." In the modern view below, the tide is in and the viewer can see that Scott's Island has overgrown considerably. (JFC.)

The Washington Woolen Mill Pants Factory was a 1909 expansion of the old water-powered Woolen Mill. When the mill burned on August 18, 1910, this operation could continue as its machinery was run by electricity. This card, published by Bond, shows the Ford Street entrance. At the time, the street was named "Factory." Employees in the top floor window enthusiastically display their product. Hand-drawn pedestrians, wearing the fashion of the day, walk by. This structure is today utilized by Dowling Signs, Inc. (JFC.)

73

The remnants of Gunnery Spring on the south end of town are a mute testimony to the tenacity this region has always exhibited. It is near here that a munitions factory was operated by early patriots like Fielding Lewis, Charles Dick, and Charles Washington. Structures on the property were later used during the Civil War as hospitals. In 1898, during the War with Spain, the site was converted into Camp Cobb, a training camp for the 4th United States Volunteer Infantry Regiment. Native-American lore has said that all who drink the water from this spring will return to drink again. Situated near the intersection of Ferdinand Street and Gunnery Road, it is directly across from the original Walker Grant School. (JFC.)

On the northwest corner of the intersection of William and Charles Streets is the building that once housed the Planters Hotel. A myth persists that President-elect Abraham Lincoln spent the evening here in December of 1860. On the corner in front of the hotel stood the auction block from which countless slaves were sold. The picture at top, published by Kishpaugh, shows several early motor vehicles. Other versions of this card were later produced that showed a former slave, Albert Crutchfield, who had been sold from the auction block in 1859 at 15. For many years, Crutchfield worked as a butcher and lived at 307 Charles Street. The modern view below shows the unfortunate loss of numerous old buildings on the south side of William Street. (JFC.)

This winter scene, published by Kishpaugh, is of the 400 block of Hanover Street. The homes along this stretch have been beautifully maintained with little alteration in nearly 100 years, as can be seen in the modern view below. This card was sent to a young lady in West Virginia by Frank Kishpaugh, the brother of Robert, the printer. Mailed on December 12, 1909, Frank wrote, "I suppose you will remember this scene. I am afraid it will be repeated to-night as it is very cloudy. The past week has been cold just 10° above 0. I hope we will have plenty of skating after Xmas." (JFC.)

Another winter scene, this time published by Bond, shows the intersection of Amelia Street with Princess Anne Street. The streets are abandoned except for a lone horse-drawn carriage that is most likely the photographer's. Being a Bond postcard, the man in the center is probably William L. Bond himself. Interestingly, this card, mailed in September 1922 to a resident in Farmville, Virginia says on the back, "We reached Fredericksburg at six o'clock. It is a quaint old place. I bought these cards, at the oldest Drug Store in America so they say." The writer is of course referring to Bond's Drug Store at William and Caroline Streets. (above, CM; below, JFC.)

At 501 Hanover Street stands the magnificent former home of Judge Alvin T. Embrey. A respected attorney, Embrey was also the secretary and treasurer of the Fredericksburg Power Company. The 1910 Embrey Dam bears his name. Standing on the northwest corner with Prince Edward Street, the original structure dates back to 1803 but has undergone extensive additions and modifications both inside and out. It has been the home of David S. Forbes until 1902 when it was purchased by Embrey. (above, CM; below, JFC.)

Directly across Hanover Street from the Embrey house is Trinity Episcopal Church seen at middle left. When Kishpaugh produced this card, Rev. H.H. Barber was the rector. In 1910, Hanover Street is still a dirt road with large carriage blocks at the curb. (JFC.)

79

On land that was once part of the estate of Kenmore, the residential neighborhood of Washington Avenue was created just before the end of the 19th century. In 1890, the Fredericksburg Development Company was organized, and soon thereafter purchased this land, that had once been part of the "open plain" between town and Marye's Heights in 1862. This early view by Bond, shows the Avenue's west lane, looking north from near the intersection with Lewis Street. A monument to Gen. Hugh Mercer, unveiled in 1906, stands in the center lawn. (JFC.)

Two more views by Bond of the picturesque Washington Avenue reveal many of the homes that are today obscured by trees. On the next page are two examples of the architectural gems that grace the avenue. (JFC.)

At left, this grand home at 1206 Washington Avenue West was constructed in 1906 from locally quarried granite by Elmer G. Heflin, architect and builder. The stone came from a quarry on the Rappahannock River, three miles northwest of town. At bottom is one of the earliest homes built in the new subdivision. In 1896, 1303 Washington Avenue East was built. It is a fine example of late Victorian design with typical wood ornaments along the porch and eaves. (JFC.)

Kenmore itself has certainly withstood the test of time. Built in 1752 for Fielding and Betty Lewis, Kenmore survived the Civil War only to be nearly demolished in 1922 in a shameless proposal by a developer. Local citizens responded with outrage when news spread of his plans. Organized as the Kenmore Association, they began to raise funds to purchase the mansion on July 6, 1922. By September 1, they made their first installment of $11,000. On January 1, 1925, the final installment was made, preserving Kenmore for future generations. This Kishpaugh image is postmarked May 4, 1911. Today Kenmore has been restored and is maintained by George Washington's Fredericksburg Foundation. (JFC.)

In 1885, *Harper's* new monthly magazine ran an article entitled, "In An Old Virginia Town." It related the history of Fredericksburg and said that, "Thirty years ago the town contained dozens of 'old citizens' who had personally known Washington and his mother, many of them as kin; they have all passed away, but their recollections and impressions, received at first hand, were of course stamped on the minds of their children who are still living." One of several engravings attached to the article is the one above, depicting the original, unfinished tomb of Washington's mother. On May 10, 1894, a new monument to Mary was dedicated before a large crowd featuring an address delivered by President Grover Cleveland. The early 1900s card by J. Willard Adams below shows both monuments in an artistic tableau, typical of Adams's product. (JFC.)

84

Monument to Mary, the Mother of Washington, Fredericksburg, Va.

This view of Mary's monument was originally published by the Rotograph Company in 1905. The monument stands on a hilltop at the northwest corner of Washington Avenue. (JFC.)

85

On this and the facing page are two views of the infamous Sunken Road, looking south toward the intersection of Mercer Street. Both are by Bond. Concealed behind trees and other vegetation are the Innis House and the stone wall from which Confederate forces kept Burnside's forces at bay. (JFC.)

Nestled at the base of Marye's Heights, the Sunken Road was also known as the Telegraph Road as it was the route of the north-to-south telegraph line. The Sunken Road has become the most notable landmark of the battles fought here. At the southern end where it intersects with modern Lafayette Boulevard, the Fredericksburg Battlefield Visitors Center is open to the public. Tours are given daily. (JFC.)

Another card in this series by Bond shows the Sunken Road from Mercer Street looking north toward the intersection with Hanover Street. Partly visible among the trees at right center are the roof and chimney of the Ebert Store. Miss Mary Ebert operated a grocery here in the 1930s. Its address was 918 Kirkland Street. At the distant left center is a house at 922 Hanover Street. It was at one time occupied by Joseph E. McCalley, a postal carrier. Both of these structures are no longer standing. Today, the Stone Wall has been cleared of vegetation and is protected by the National Park Service. This is the only section of the original wall left standing today. (JFC.)

This is a photograph of the Ebert Store, taken in the late 1920s by Miss Frances Benjamin Johnston, who had been commissioned to make a record of historic structures by a local patron. Below, the same view today, looking east, reveals the stone wall as it takes the corner around Kirkland Street. (above, LC; below, JFC.)

This 1905 view (top) and the modern view (bottom) of the Sunken Road look north with the intersection of Mercer Street and the Innis House at middle right. At left, on the edge of the road is a monument to Confederate general Thomas Reade Rootes Cobb, who was mortally wounded by an artillery shell that passed through a house in front of which he stood, December 13, 1862. (JFC.)

This is a very early postcard of the United States National Military Cemetery on top of Willis Hill, above the Sunken Road. The cemetery was begun on July 15, 1865. In this view, published by J. Willard Adams, we are looking northeast toward the former Monfort Academy site. An earthen mound and flagpole occupied the space where a monument to Humphrey's Division stands today. The modern view below shows *Humphreys' Monument* sculpted by Herbert Adams in 1908. Take note of the large cemetery stone at middle right in both pictures. It will be seen in detail on the next page. (JFC.)

"On Fame's eternal camping-ground
Their silent tents are spread
And Glory guards, with solemn round,
The bivouac of the dead."
–Theodore O' Hara

This is the tombstone of Sgt. Edward L. Townsend. The inscription has deteriorated so severely that it can no longer be read beyond the first line. Townsend enlisted on August 30, 1862 for nine months service in the 25th New Jersey Infantry, Company I. During the battle of December 13, 1862, Townsend received a mortal gunshot wound to his side. He succumbed to the injury on December 14. He was initially buried at "Reynold's Lot," but later reinterred in the National Cemetery. Reynold's lot was at the intersection of Princess Elizabeth Street and Caroline Street. This stone was apparently purchased by his family. Townsend has the bizarre distinction of having two burial locations within this cemetery, locations 2292 and 2660. There is no known explanation for this. (JFC.)

NATIONAL CEMETERY,
SHOWING GEN. HUMPHREY'S MONUMENT.
FREDERICKSBURG, VA.

This Kishpaugh card of the impressive *Humphreys' Division Monument* looks west across some of the 15,300 graves that fill the Fredericksburg National Cemetery. Humphreys himself was not a casualty of the war, but the division he led against Marye's Heights suffered heavily under the withering gunfire from behind the stone wall. As seen in the modern view below, the cemetery is carefully maintained by the National Park Service. Each Memorial Day weekend, a Luminaria is held to honor the dead with a candle lit for each of the internments. (JFC.)

The National Cemetery, Fredericksburg, Va.

Another c. 1905 postcard shows the terraced slope of the National Cemetery. At the base of the hill is where Sunken Road and Lafayette Boulevard intersect today. In the modern view below, the *Fifth Corps Monument* is more visible over top of the trees near the base of the hill. For many years, this monument was called the *Butterfield Monument* in honor of former Corps commander Daniel Butterfield, who led his troops against the heights. On May 25, 1900, President McKinley attended a ceremony for the laying of the monument's corner stone. The completed monument was dedicated on May 30, 1901. Butterfield himself died July 17, 1901, and is buried in West Point New York. (JFC.)

General View of Gettysburg, Pa., in 1863.

This card is a view of Fredericksburg being presented as Gettysburg, Pennsylvania. The back of the card claims, "This picture is reproduced from original photo taken by staff photographer of the U.S. War Department, on July 1, 1863, and shows Gettysburg exactly as it appeared on the eve of the great battle." The card is postmarked from Gettysburg on July 17, 1922. In reality, the image was taken around May 19 or 20, 1864. Slightly to the right of the center is the site of the Joseph Hall house, now the location of the Fredericksburg Battlefield Visitors Center. Hall's house had been dismantled by the spring of 1864, but he apparently rebuilt soon after as a dwelling appears with his name attached in an 1878 map of Fredericksburg. As seen in the modern view below, the *Butterfield Monument* is at center. (JFC.)

This is the gigantic Woolen Mill in 1864, being used as a hospital for the wounded of the Federal Fifth Corps. After the war, the mill was refitted with machinery and put back into operation. Eventually it would become one of the town's major employers with 300 people working at the enlarged facility in 1910. While under the management of John Melville, the mill caught fire August 18, 1910 and was a complete loss totaling $150,000. The modern view below is virtually unrecognizable from the corner of Pelham Street and Princess Anne Street, looking east. (above, LC; below, JFC.)

Shown above is the abandoned waterway of the Fredericksburg Water Power Company as it led toward a turning basin located near Canal Street and Prince Edward Street. Waterpower continued to bring industry to the post war economy of the area. Eventually, waterpower was used to generate electricity. One of the facilities built to harness that power was that of the Spotsylvania Electric Company, seen below, along upper Caroline Street near the ruins of the Germania Flour Mill. (JFC.)

This is the place where George Washington's mother would go to rest and study her Bible. Known as Meditation Rock, it is located behind the Gordon Cemetery and her tomb on Washington Avenue. This c. 1905 postcard is of added interest due to the industrial facility visible in the left background. Seen below is an enlargement of that facility. It stands on the site of what was a paper factory at the time of the Civil War. In this photograph, we see the buildings of the Cartwright and Davis Marble and Granite Works who quarried stone along the Rappahannock River. The flat, white area to the left of the large structure is the 9,000,000-gallon settling basin for the City Water Works Pumping Station. (JFC.)

French general Lafayette, whose assistance at Yorktown helped win the American Revolution, was entertained here on his visit to Fredericksburg in 1824. Known as Union House, this giant, brick structure had been built in the early 19th century as a private residence. It would later serve as a public school until the fall of 1909 when a new building was completed on the property behind it. The picture above was taken on the last day of school, May of 1909. That school was eventually outgrown and the building is now the headquarters of the Rappahannock Regional Library at the intersection of Caroline and Lewis Streets as seen below. (above, CM; below, JFC.)

The postcard above shows the new public school after demolition of Union House. Postmarked September 4, 1909, the card has an interesting story of its own. This is another card sent by Frank Kishpaugh, Robert's brother. It was sent to the same young lady in West Virginia to whom he sent the snow scene of Hanover Street. He writes, "What do you think of our new school building? It will be used for the first time beginning Monday the 6th. It cost about forty-five thousand dollars and is far better and handsomer than any school building in the State. This card was made from a photograph I took." The clock tower has since been removed as seen in the modern view below. (JFC.)

An early institution of higher learning was Fredericksburg College, seen in this card published by J. Willard Adams. Posted on February 18, 1907, it shows the girls dorm on the left with its residents posing on the porch. The building to the right is the actual school, which had previously been a private residence—the home of John Chew. Sometime after the school ceased to operate, the dorm was dramatically altered and became a medical center. Today it serves as apartments and the school is once again a private residence. The buildings are on the northwest corner of Prince Edward and Lewis Streets. (JFC.)

In the 1960s and 1970s, the former Chew house at 1202 Prince Edward Street was the location of Stoner's Store, a museum. It contained a large collection of 1800s store merchandise. Elma Bond, daughter of Dr. William LeRoy Bond, worked there as a hostess and guide until 1974.

Wallace Library, Fredericksburg, Va.

The Wallace Free Library at 817 Princess Anne Street was completed in March 1909 through a bequest of Capt. C.W. Wallace. Wallace had been a longtime member of a library committee and later served on a land improvement committee. Wallace left $15,000 to the aspiring city with no more than one third of the funding to be used for the actual construction of the library. The remainder was to be used for the acquisition of books. Today, the Central Rappahannock Regional Library is in the old high school building on Caroline Street and the Wallace building is used as the city school board offices. (JFC.)

Another major improvement to the town was the construction of the first Mary Washington Hospital at the corner of Faquier and Sophia Streets. Annie Myer was one of the many local ladies who helped to organize fund raising in 1897. Fund-raisers were held at the Opera House, the first on February 26, 1897. A cornerstone ceremony was held on April 13, 1899. John Henry Myer Jr. donated the stone from the remains of the original Mary Washington monument, which had been left lying alongside the Gordon Cemetery wall. Work progressed quickly and the hospital was dedicated on October 14. A little over a year later, John Henry Myer Jr. underwent an appendectomy at the hospital, but it was too late to save his life. He died on November 14, 1900. He had recently celebrated his 48th birthday. (JFC.)

103

The two views on this page are representative of some of the older architecture that has been destroyed throughout town. They were photographed as part of the Historic American Buildings Survey in the 1930s. In dilapidated condition, they offered nothing of beauty, but what could they have provided today if they had been restored? Above is the 700 block of Sophia Street looking west. Below are warehouses that once thrived near the City Dock, looking north. (JFC.)

Here, as they appear today, are the same locations from the previous page. A visitor from the past would have a hard time recognizing this former hub of international commerce. After the turn of the century, Sophia Street was mostly populated by former slaves who lived in what had become dilapidating tenements.

Today, the City Dock has been transformed into a park. A marker near the foot of Sophia Street pays tribute to the "Irish Brigade." Formed primarily by men of Irish descent, they distinguished themselves during the December 13, 1862 attack against the Stone Wall. The Brigade's losses were staggering—approximately 45 percent.

The picture at top is another enlargement of the town panorama from page 22. At right is the warehouse of Marye's Mill. The house at center was long ago demolished. The small frame building at left has survived the many ravages of time. War, floods, and economic upheaval have taken a toll on this section of Sophia Street. Amazingly, this house remains standing as a lone, silent testament to an era now gone. The view at bottom shows the house from the intersection of Frederick and Sophia Streets today. An addition was put on the left side by 1891 when the former Marye's Mill was operating as Ray and Pettit's Excelsior Flour Mill. (JFC.)

Dr. William L. Bond, druggist and postcard publisher, stands in front of one of Fredericksburg's controversial landmarks. Used as a grocery store, this building had once been the home and tailor shop of William Paul, a Scottish immigrant who settled here in 1750. His younger brother would one day become Revolutionary War naval hero John Paul Jones. After William Paul's death in 1774, it is said that John Paul Jones rented this property from his brother's estate executors. However, there are no records to substantiate this claim. The building stands on the corner of Caroline Street and Lafayette Boulevard. It is currently undergoing extensive restoration to return it to its Colonial-era appearance. (JFC.)

The Georgian-style mansion known as Federal Hill once stood on the edge of Fredericksburg, but today, it is surrounded by the expanding city. Built c. 1795 by Virginia governor Robert Brooke, it was next owned by Thomas Reede Rootes, the grandfather of Confederate general Thomas R. Rootes Cobb. After the December 1862 battle, the house was used as a Union hospital. It has been surmised that General Cobb was mortally wounded by a shot fired from a Union artillery position on Federal Hill while he stood at the base of Marye's Heights. Both views here were taken around the late 1920s. (JFC.)

Nationally recognized Civil War reenactor and outspoken battlefield preservation advocate Robert Lee Hodge addresses a meeting of the Spotsylvania Battlefield Education Association on the evening of January 17, 2002 at Federal Hill. The meeting was held in the ornate ballroom. Since the death of owner Elizabeth Lanier in 1996, considerable effort has been made to fulfill her wish to see Federal Hill restored in perpetuity. Her desires were to see the home used for historic purposes and to foster further research and promotion of the home in its historic context. To that end, the executors of the estate established the Federal Hill Foundation. The modern view below was taken from the remains of an artillery lunette on the western lawn of the property. (above, JB; below, JFC.)

On lower Caroline Street, many of the fine homes were in the midst of the Union bombardment of 1862. One of those treasures is known as the Sentry Box, built around 1786. It was once the home of Revolutionary War general George Weedon. In 1862, it was the residence of the Mason family. The postcard above shows the home around 1905. The Sentry Box was seriously damaged but has been faithfully restored to its antebellum appearance, as seen below. (above, CM; below, JFC.)

Across the Rappahannock to the north is the town of Falmouth, a former industrial rival to Fredericksburg. Occupied by Federal troops throughout the Civil War, all of Stafford County was ruined. Virtually denuded of trees, Stafford's economy would not begin to recover until the First World War when the Marine Corps Base at Quantico was established. This building had been standing on the corner of Cambridge Street and King Street since the early 1700s. It was destroyed in the 1940s, around the time the new Falmouth Bridge was constructed. (JFC.)

111

On Princess Anne Street across from the circuit court building was the French Memorial Chapel, erected in 1880. The chapel was a gift to the Presbyterian Church from the Seth Barton French family in remembrance of their daughter Margarette, who died at the early age of 21. (JFC.)

The French Memorial Chapel, with three Tiffany stained-glass windows, was destroyed by a fire that erupted from a faulty furnace on January 14, 1954. It was replaced in 1967 by the above structure named the French Memorial Education Building. The original iron fence still surrounds the building. (JFC.)

Above is the home of Robert Kishpaugh at 1201 Prince Edward Street. Kishpaugh published countless postcards and numerous picture books devoted to the history of Fredericksburg. He began his profession as a printer in 1894 when he was 15. He was the founder of Kishpaugh's Stationery Store, which operated continuously under his ownership for nearly 70 years, originally at 918 Caroline Street and later at 214 William Street. He died at his home April 20, 1965 at the age of 86. He is buried in the Confederate Cemetery. Robert A. Kishpaugh has another distinction in town—he purchased Fredericksburg's first automobile, a Cadillac, which arrived on April 26, 1906. The historic "first garage" is behind his home, as seen below. (JFC.)

Above is the home of druggist and postcard publisher Dr. William L. Bond at 1205 Prince Edward Street, two doors down from Robert Kishpaugh. Bond was born in Marion, South Carolina in 1866. He purchased the old Hall's Apothecary in 1907 and operated it until his death at age 80 in November of 1946. Below is the home of Joel Willard Adams Sr. and Jr. at 1500 Caroline Street. The elder Adams operated Adams Book Store beginning just before the Civil War and continued until his death in 1898. His son continued the business until 1926 when he sold it to D. William Scott and Charles A. Charmichael. Adams retired from his family business to devote time to his duties as Clerk of the Court and other endeavors. (JFC.)

In his later years, John Henry Myer moved in with his daughter Mary's family, the Eckenrodes at 1101 Caroline Street on the corner of Amelia Street. At 80, he retired from the mill and stepped down from his position on the common council, much to the disappointment of his constituents. They understood because he had served them with dedication. In 1915, Mary sold the property at the Caroline Street address and moved to 1405 Washington Avenue with her sister Annie. The Eckenrode Building (as it had become known) was converted by its new owner, William J. Tinder, into a boarding house. A porch was extended across the front of what had been a duplex. The Kishpaugh card above is from the 1930s. (JFC.)

115

On December 5, 1909, after an attack of paralysis, John Henry Myer passed away in his sleep. At 83, he had spent over 60 years in Fredericksburg. His obituary remembered him as "a man of strictest integrity, active and progressive in his business life, a member of the Presbyterian Church, a Mason and an honored citizen." Myer is buried in the family plot in the Confederate Cemetery on Washington Avenue. (JFC.)

Five

MEMENTO MORI

Life is fragile. We either endure or succumb to adversity. John Henry Myer lived a life of fortitude. With the strength of Job, he survived war and loss of property. The year after the accident that destroyed the Germania Flour Mill, Myer lost his wife. "Fell asleep in Jesus, on the morning of May 24th, Mary Elizabeth, aged 50 years, 6 months and 7 days, devoted wife of J H. Myer Esq.," was all that was on the simple death announcement. On August 5, 1887, a local newspaper, The Free Lance, carried a small piece of information. "Squire Myers has been quite a sufferer with chills for the past week. He says he can stand chills fairly well, but a broken leg mule and a dearth of official business is compensated for only by the rapid growth of his present corn crop. In answer to the enquiry which he'd rather do or go a fishing? Replied 'to bed and go to shleep.' This may be considered by the Squire, another piece of the Lance's 'damphoolishness.'" In February of 1884, seven months after giving birth to a daughter, John Junior's wife Annie died. She was 28. When John Junior prematurely died in 1900, the newspaper reported, "The deceased was an upright Christian gentleman, a dutiful son, the constant companion of his father, and it has been remarked that they were more like brothers than father and son." These are the events that fill our lives. As a community, Fredericksburg strengthened through its suffering.

This photograph was taken about 1908 in the backyard of 1101 Caroline Street. John Henry Myer is at right. His eldest daughter, Mary Eckenrode, is at center and one his grandsons, Hamilton Myer Eckenrode, is at left. Seated in front of her father is Frances Cornick Eckenrode. Here are four generations assembled for a final portrait. (AL.)

At 605 Lewis Street, Hamilton Myer Eckenrode built this house in the late 1920s. He was a dentist and his office was above Goolrick's Pharmacy at the corner of Caroline and George Streets. He died in 1937 at the age of 64. The building has since become the headquarters of George Washington's Fredericksburg Foundation. (JFC.)

Frances Cornick Eckenrode became the first graduate of the State Normal School's Fourth Year Degree Class in 1923. (JFC.)

Normal School, Fredericksburg, Va.

The State Normal School, chartered in 1908, was built along the northern end of Marye's Heights. This Kishpaugh card, mailed June 24, 1920, shows the school as Frances Cornick Eckenrode knew it. Monroe Hall is at right and Frances Willard Hall at left. (JFC.)

Another grandson was Dr. Hamilton James Eckenrode, who became a Virginia State historian and archivist. He was responsible for the historical marker program begun in 1926. He also authored numerous books, including a biography of Confederate general James Longstreet. He died in 1952. In this photograph, he is seen cruising the Rappahannock with, from left to right, an unidentified friend, his cousin Mary Elizabeth Eckenrode, and his sister, Elizabeth Eckenrode. (AL.)

One of the casualties of the fighting on Myer's Hill on May 14, 1864 was Corp. John C. Hensler of Company E, 2nd New Jersey Infantry. During the Union retreat, Hensler was struck in the back of the head by a bullet, which suspended in a perforation of the occipital bone. He would die from complications of the wound on June 4, 1864 at Harewood Hospital in Washington, D.C. (NMHM.)

Another fatality of the Myer's Hill action was Lt. Col. Charles Wiebecke, commanding the 2nd New Jersey Regiment. He was initially buried in the orchard next to Myer's house, but was later re-interred in 1876 in the National Cemetery, Fredericksburg. Eventually he was moved to Fairmount Cemetery in Newark, New Jersey. In the photo below, C. Hobson Goddin, of Richmond, Virginia, displays the sword of Charles Wiebecke, taken from the dead colonel's body by Goddin's great grandfather, Capt. John David Hobson of Company F, 4th Virginia Cavalry. The picture was taken in the yard of the Myer home, October 31, 2001. (JFC.)

The Confederate Cemetery on Washington Avenue was begun after the war by the Ladies Memorial Association, a group of local women who saw to the necessity of honoring the men who served the Confederacy. In 1884, a monument was erected that overlooks the graves. The early 1900s view above shows the open ground beyond the cemetery with Marye's Heights on the horizon. It is on this section of the heights that the State Normal School was built. Since 1972, the school has been known as Mary Washington College. In the modern view below, the open plain between the cemetery and the heights has been subdivided and developed into a residential neighborhood. (JFC.)

An obscure, lonely grave in the cemetery, not far from the Myer family plot, is that of Pvt. William Starke Jett. "Willie" had the great misfortune of meeting a couple of mysterious strangers on April 24, 1865 at Port Conway on the Rappahannock. The strangers ended up being Lincoln assassin John Wilkes Booth and his coconspirator, David Herold. Jett reluctantly aided Booth by taking him to the Garrett Farm near Bowling Green. The next day, Federal Cavalry that had been in pursuit of Booth were tipped off about Jett and they apprehended him at Bowling Green. Jett led them to the Garrett Farm where Booth met his demise. Willie Jett served briefly in the Confederate service, and when he died in an asylum in Williamsburg, Virginia, his family asked that he be buried in the Confederate Cemetery. (above, MWK; below, JFC.)

123

Near the Confederate Cemetery is the home of Joseph Walker at 709 Amelia Street. Walker lived here until his death on June 3, 1943. He is buried in the Shiloh Cemetery on Monument Avenue. His grave marker reads, "Sound in Judgement, Courteous, Industrious, Reliable: A Churchman and Benefactor." (JFC.)

The study of our history continues unabated today. Extensive archaeology was conducted in 2002, as part of a rehabilitation project on the Market Square in Fredericksburg. Under the direction of Mary Washington graduate Josh Duncan, the program discovered seven forgotten graves of the former St. George's Church lot that was moved in the 1950s. The burials dated to the mid to late 1700s.

On August 14, 2000, the Spotsylvania Battlefield Education Association held its inaugural event, the John Henry Myer Night. It was held in a building that once housed a stove shop owned by John Myer Jr. in the late 1880s. Gathered at the event are, from left to right, Vice-Mayor Gordon Shelton, John Cummings (SBEA), Robert Williams (Friends of the Fredericksburg Area Battlefields), and Mayor Bill Beck. (above, JFC; below, VB.)

125

At Spotsylvania, veterans of the Union VI Corps erected a monument to their fallen commander, Gen. John Sedgwick, on May 12, 1887. Near this spot, Sedgwick was killed by a sniper's bullet. The general had just jokingly admonished his troops for dodging random bullets. "What would you do if they opened up on the whole line?" he questioned. "Why, they couldn't hit an elephant at this distance." The image above is c. 1905. (JFC.)

On May 12, 1918, a group of local ladies saw to the erection of this monument to the Confederate Dead in the Confederate Cemetery near Spotsylvania Court House. Nearly 600 soldiers are buried there. This postcard is from around 1920. (JFC.)

The Spotsylvania Court House suffered severe damage during the battle of May 1864. It was situated less than a mile behind the Confederate center. By 1901, the structure was determined to be unsafe. New exterior walls were built over top of the old ones along with other modifications. The brick wall that surrounded the lawn was also dismantled. Both images here illustrate the post-1901 court house. The bottom photo shows a wing that was added in 1964 for county offices. (JFC.)

This photograph, dated 1868, was taken by Fredericksburg photographer F. Theodore Miller. It has a notation on the back that it was given by Emma Miller to the Myer family in 1873. A group of young boys and a dog are on the lawn of Kenmore, near Mary Washington's grave. Across the background can be seen the three spires (both churches and the Circuit Court), as well as Kenmore's distinctive roof. (AL.)

About the Author

John Cummings is a freelance writer and artist. He is the director of the Spotsylvania Battlefield Education Association (SBEA). SBEA is a non-profit group dedicated to the research, analysis, and dissemination of information regarding the battle fought at Spotsylvania Court House and its environs.

SBEA provides a rich educational experience for people to learn about the battle in its full social, political, and cultural context. Visit their website at www.spotsylvaniabea.org. SBEA is an affiliate of Friends of the Fredericksburg Area Battlefields (FOFAB). John also serves on the Spotsylvania Courthouse Tourism and Special Events Commission.